IMAGES
of America

KENT

ON THE COVER: The Kent Valley School placed emphasis on not only academic excellence, but also art education. Many of Kent's social clubs in the early 20th century would put on small performances and exhibitions would pull double duty as showcases and social gatherings. In the spring of 1922, students at the Kent Valley School put on a production of *The Stolen Flower Queen*. (Courtesy of Greater Kent Historical Society.)

IMAGES of America
KENT

Rachel E. Friedland

Copyright © 2025 by Rachel E. Friedland
ISBN 978-1-4671-6222-7

Published by Arcadia Publishing
Charleston, South Carolina

Printed in the United States of America

Library of Congress Control Number: 2024952008

For all general information, please contact Arcadia Publishing:
Telephone 843-853-2070
Fax 843-853-0044
E-mail sales@arcadiapublishing.com

Visit us on the Internet at www.arcadiapublishing.com

*To my wonderful family, for their unending support, and to
Athena, who helped me Spare a thought to research again.*

CONTENTS

Acknowledgments		6
Introduction		7
1.	The White River Valley and Early Kent	9
2.	Farming and Logging	19
3.	Schools	35
4.	Forming a Community	47
5.	Trains	69
6.	Downtown Kent	73
7.	Japanese Immigrants and World War II	105
8.	Vanishing History and the Postwar Years	117

Acknowledgments

A special thanks to the amazing staff and volunteers at the Greater Kent Historical Society (GKHS) and the countless time and work contributed to this publication. This would not have been possible without their support. The majority of the photographs selected were from the careful cataloging and research of GKHS.

I would also like to thank the Museum of History and Industry and the White River Valley Museum, for their contributions to this book.

INTRODUCTION

Kent, Washington, spans from West Hill to East Hill, crossing what is now called the White River Valley. The indigenous populations were called the Coast Salish People. The tribes that lived on the hills surrounding the valley were primarily Duwamish, but other tribes would pass through. The valley itself was often more river than land; frequent rainfall would raise the banks of the Green River and Mill Creek enough to make travel by canoe necessary. This yearly flood pattern continues today, but since the construction of the Howard Hanson Dam in 1961, rising water levels have been contained to the shore of the Green River and surrounding farmlands.

The area was desirable for European settlers for the rich farmland and opportunity for logging. The abundant red cedar in the area was excellent for use in the construction. Lumber could be felled on the hills, rolled down skid rows, and ferried north to Seattle and south to Tacoma. The construction of Fort Nisqually by the Hudson's Bay Company in 1833 made the White River Valley a viable place to live for white settlers. In an effort to colonize the land, the 1846 British-American Boundary Treaty promised hundreds of acres of land to farmers willing to work the land and live in the region for at least five years. The fecund soil yielded bountiful harvests of lettuce, beans, peas, berries, and most profitable: hops. The similarity to the county of Kent in England caused many to adopt the moniker for the growing farming community. The name was used colloquially for years until the Northern Pacific Railroad used it to refer to the region and build a depot for passenger and commercial transport. Made official, the township of Kent was born.

After the railways were completed in the late 19th century, lettuce and hops sales grew exponentially, creating steady growth of wealth among White River Valley farmers. The economic opportunities were a draw not only for pioneers from the East Coast and Midwest, but also for Asian immigrants as well. Japanese Americans took on both farming and business roles and were so ingrained in the Kent community that it was not uncommon for Japanese women to wear kimonos to formal events.

The once robust industry of family farming declined over the years, partly due to postwar industrial growth, but also because of the expulsion of Japanese Americans in the 1940s as a response to the bombing of Pearl Harbor. A lower population led to labor shortages that were not fully recouped. Local government recruited volunteers made up of families and even school groups to fill the gap. Despite the upkeep for the war effort, many Japanese-owned farms were seized and sold off, the proceeds withheld from their previous owners.

After the end of World War II, Kent began to increase its business ventures outside of farming. School districts merged and grew, companies expanded, and much of the land was rezoned and developed. Logging on East Hill gave way to commercial ventures; once two-lane highways gradually became wider to accommodate greater traffic needs. More recently, major businesses like REI and Amazon have chosen to build facilities in the valley. Most notably, it is home to over 130,000 people who work in offices and on farms and call the beautiful city their home.

One
THE WHITE RIVER VALLEY AND EARLY KENT

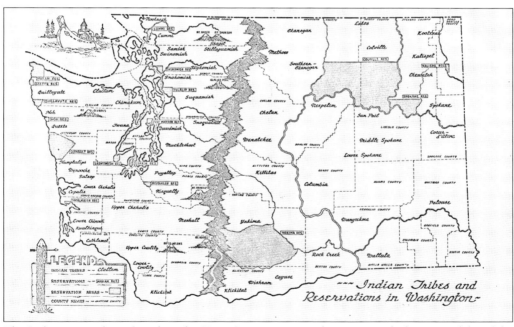

The Indigenous tribes of modern-day King County were made up primarily, but not solely, of the Duwamish and Muckleshoot tribes. They lived in longhouses in the hills, traversing the flooded valleys in canoes when needed. The tribes along the Puget Sound, or the Salish Sea, belong to a larger group called the Coast Salish People, with nations spanning from British Columbia down to Northern Oregon. Still a vital part of the Western Washington community, their nations are federally recognized by the US government. (Courtesy of Greater Kent Historical Society.)

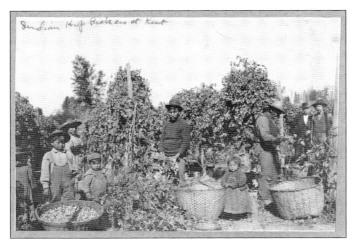

The indigenous people of King County were the Muckleshoot and the ancestors of the Duwamish: the Stkamish, Smulkamish, and Skopamish peoples. These groups lived in longhouses and traveled via canoe. During summer months or long journeys, they would construct temporary shelters made of burlap that could be put together or disassembled easily. (Courtesy of the Museum of History and Industry.)

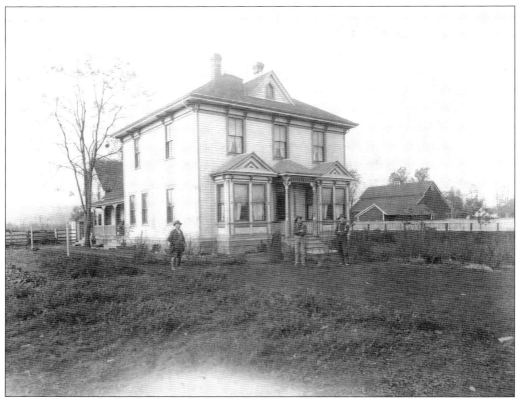

The British-American Boundary Treaty in 1846 and the Donation Land Act of 1850 promised hundreds of acres of land to white settlers who could improve the land and stay for a minimum of five years. This drew thousands of pioneers such as the Nelsons, pictured here, to settle in the valley and use their land to either farm for produce such as hops and lettuce, or purchase animals that could graze on the abundant vegetation. This house stood across from the White River Feed Company in Thomas, a township in the south of Kent. (Courtesy of Greater Kent Historical Society.)

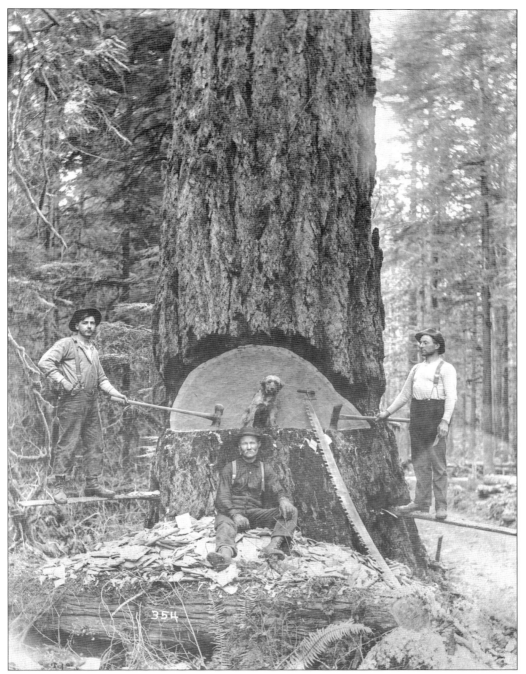

Kent's East Hill, was a draw for early white settlers as the perfect place to establish logging companies. The plateau was abundant with red cedar, which could then be transported down the Green River into the valley. The earliest skid roads in Seattle quickly inspired Kent farmers to do the same, and large swaths of land were rapidly cleared. The deforestation took its toll, and some wetlands were later protected by the US government to ensure the Hill could still maintain its ecosystem. (Courtesy of the Museum of History and Industry.)

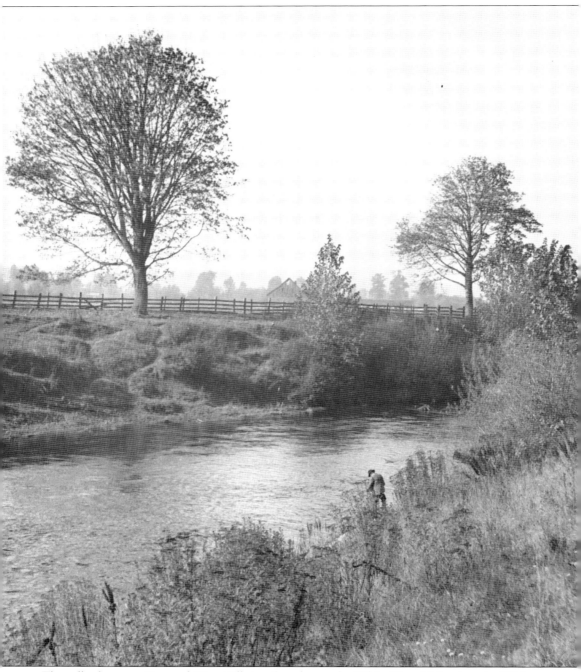

The valley between East and West Hills is referred to as the White River Valley, but the White, or Puyallup River, lies far south of Kent. The bodies of water that run through the city are the Green River and Mill Creek. Before it was dammed up, the Green River's water level used to be high enough to accommodate small ferries, and shipping north to communities like Orillia could be done by water as well as by land. Currently, the water level is lower and goods are transported by land only. (Courtesy of Kent Historical Society.)

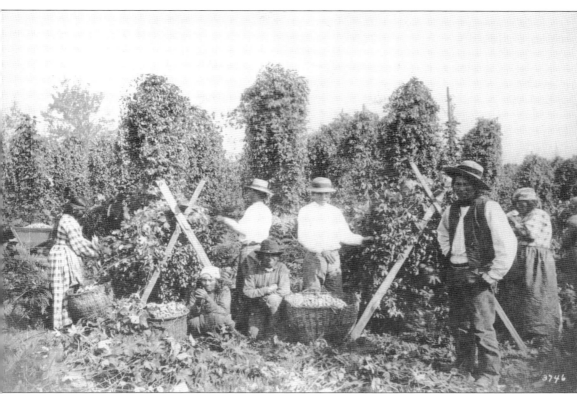

A large draw for settlers to move to Kent, Washington around 1890 was because of its fertile soil for farming in the valley. Hops, especially, were easy to grow and maintain through years of heavy flooding. White farmers drew comparisons to the area with the county of Kent in England, also known for growing hops. The city had been referred to as Titusville, but this moniker did not prove to be popular. Once rail lines began to refer to the stop as "Kent," the name remained. (Courtesy of Greater Kent Historical Society.)

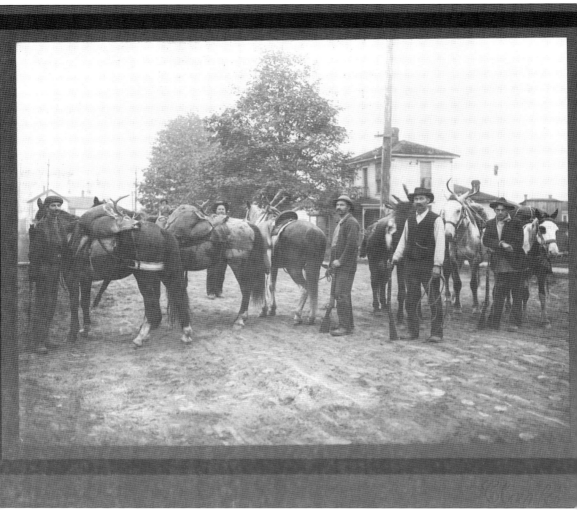

After amassing his fortune, Irving Alvord, shown here holding a coil of rope, built his homestead in Thomas, close to the former site of Fort Thomas. The fort was built to keep peace between white settlers and the indigenous tribes following the killing of a settler family in the valley. The fort did not last long, but the legacy was remembered, and the area that was Thomas was equated with Auburn, then called Slaughter. Now, Thomas is a neighborhood of Kent. (Courtesy of Greater Kent Historical Society.)

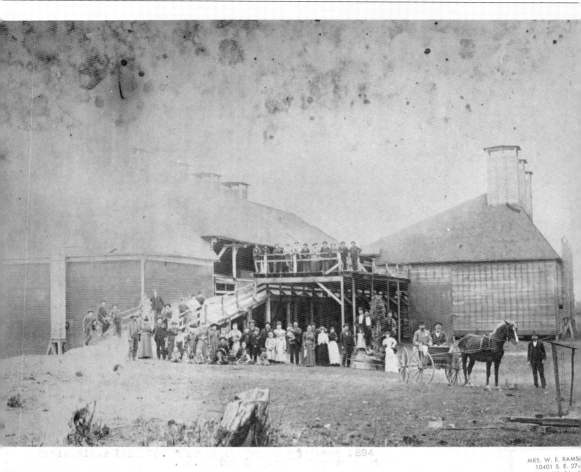

One of Kent's most famous businessmen was not a full-time resident of Kent, but rather Puyallup, a settlement about seventeen miles south. Ezra Meeker, seated to the right in the cart, owned the Horseshoe Hop Farm and White River Company in Kent during the 1890s. His property employed many farmers in the area and a street in downtown was named after him. (Courtesy of Greater Kent Historical Society.)

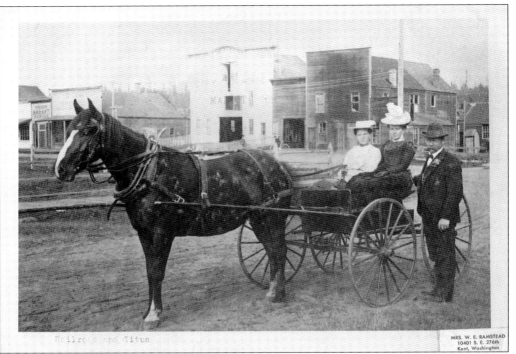

One frequently traveled street in downtown Kent is named Titusville, after James Titus, a prospector, pioneer, and farmer who lived with his wife and eight children along First Avenue. His wife, Sarah, became a land agent after she helped her husband plot the land on new maps in the 1880s. James Titus served as the second mayor of Kent. For a time, the land around his property was called Titusville. The name was given up when the Northern Pacific Railroad used the more popular moniker, Kent. (Courtesy of Greater Kent Historical Society.)

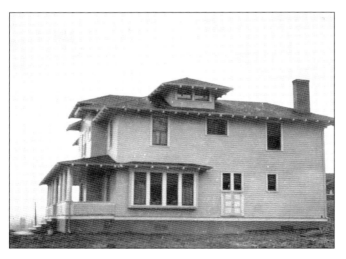

One of the most notable pioneer names that is remembered in Kent is the Alvord family. Its patriarch, Thomas Moody Alvord, was a valley farmer in Thomas who found financial success in his endeavors. On the banks of the Green River, he built a dock to better transport goods. He even tied milk cans to ferries to dangle in the water to stay cold. His reputation gained him respect in the community, and his family home appeared on postcards. (Courtesy of Greater Kent Historical Society.)

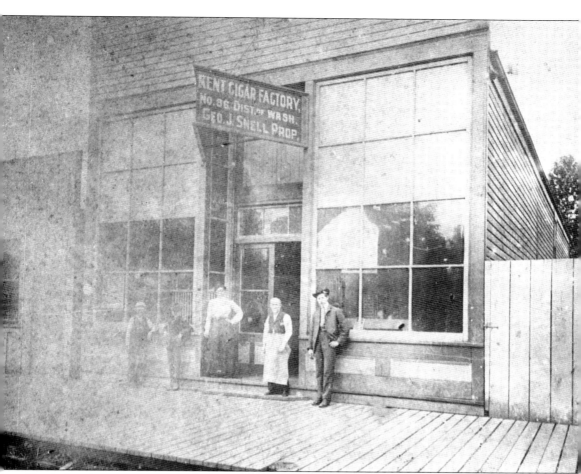

Kent's first downtown area was built out of wood, as it was the closest and cheapest resource. As the valley was prone to flooding and mud, the dirt roads needed to be kept away from the doors. As early as 1900, wooden sidewalks were built all over the valley; between shops, over train tracks, and even across farms, the sidewalks kept people and goods from sinking down into the muck. (Courtesy of Greater Kent Historical Society.)

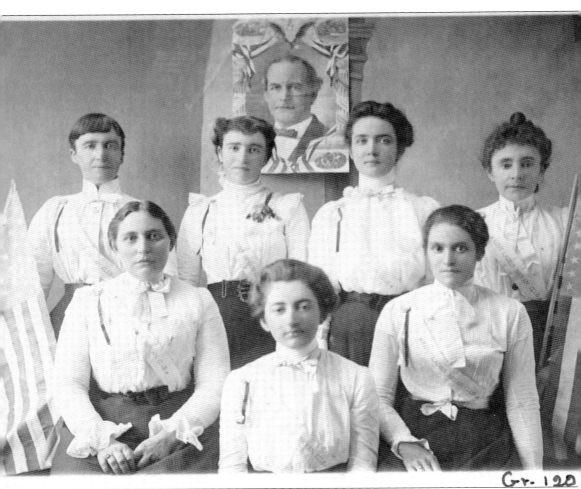

Voting rights were more widespread before Washington gained statehood. Between 1883 and 1889, women in the Washington territory could vote on public policy. Later, even while women in Kent did not have the right to vote in presidential elections, they demonstrated a sense of civic duty and campaigned for their choice of candidate, even if those campaigns were not successful, as was the case for William Jennings Bryan. (Courtesy of Greater Kent Historical Society.)

Two
Farming and Logging

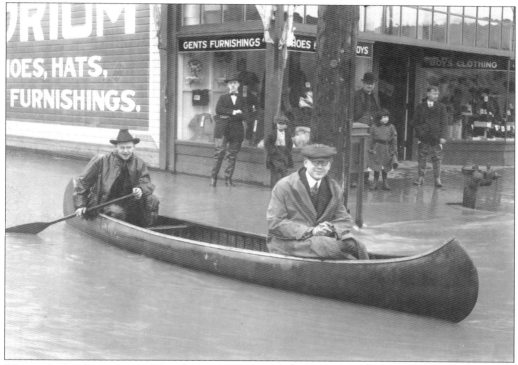

The yearly floods were a small hindrance as a part of daily life in the valley. Here, local Dr. Hoffman is rowed in a canoe during the worst of the downpour. Yearly rainfall in Kent caused the Green River to flood significantly in winter and fall. Although logging took place on East Hill, farming and the railroad were in the valley, and residents simply lived with it. (Courtesy of Greater Kent Historical Society.)

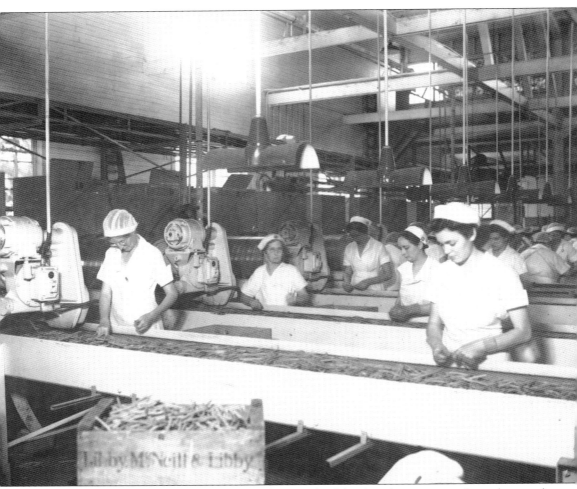

A community surrounded by and immersed in farmland developed an economy dependent on the land, but not all residents were direct farmers. Companies like Libby, McNeill, & Libby and the White River Packing Company were two major businesses that operated the distribution of goods after they left the fields. The men and women who worked for these companies were not restricted to the valley either, and many lived further up on East and West hills. (Courtesy of Greater Kent Historical Society.)

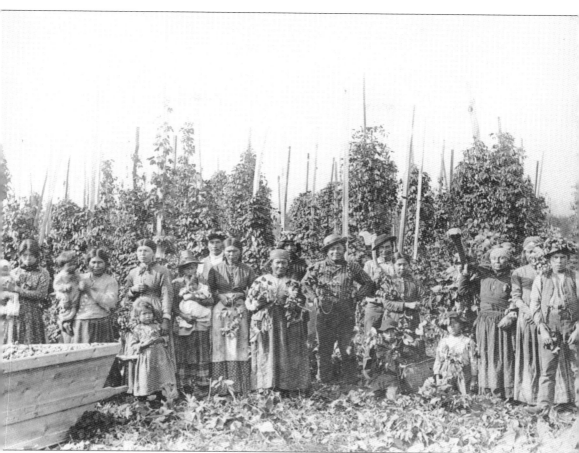

The hop harvest was a considerable affair in the White River Valley and was not limited to white settlers in the area. The local Duwamish, Sammamish, and Puyallup tribes would travel the area to pick the hops in the fall. Autumn in the Valley meant consistent rainfall and shallow flooding. Traditionally, local nations like the Duwamish navigated the area by canoe, and the harvest migrations were no exception. (Courtesy of Greater Kent Historical Society.)

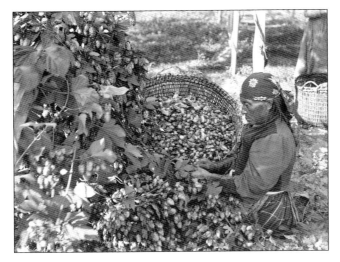

As the primary crop for so long, hop production did see a small downturn with the 18th Amendment, prohibiting the manufacture and sale of alcoholic beverages. This did not stop the residents of Kent. Stills and liquor seized by the police would often mysteriously vanish, unable to be recovered as evidence. In one apocryphal story, many barrels of gin seized by law enforcement transformed into barrels of water just before the trial. (Courtesy of Anders Beer Wilse Photographs, the Museum of History and Industry.)

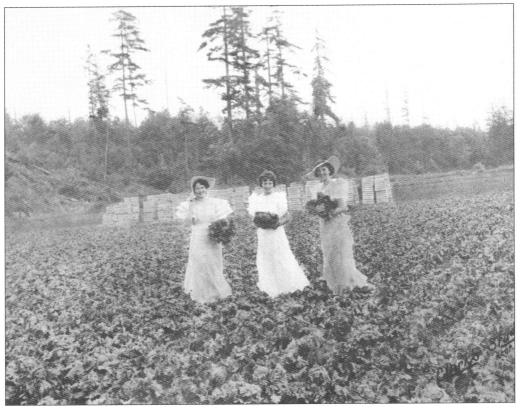

Although known widely for the hops crop, Kent also gained fame for its lettuce exports which were distributed widely throughout the state. To celebrate the harvest and the farmers who worked for it, the Kent Lettuce Festival was established. The first celebration took place on June 9, 1934, and included a Lettuce Queen and her court. The first queen, selected by community vote, was Virginia Smith (center), and her two "princesses" were Cleo Caldwell and Enis Genazzi, local high school students. (Courtesy of Greater Kent Historical Society.)

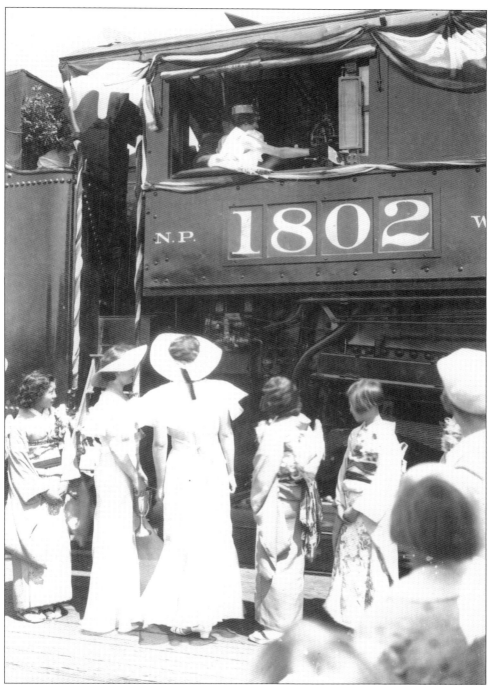

One draw of the Lettuce Festival was the opportunity to have photographs taken while dressed in festival garb. Attendees were encouraged to don their best outfits, and that was not limited to white residents. Although a Japanese American girl was never chosen as the Lettuce Queen, they were often on the court and were requested to wear traditional kimonos to celebrate their heritage. (Courtesy of Greater Kent Historical Society.)

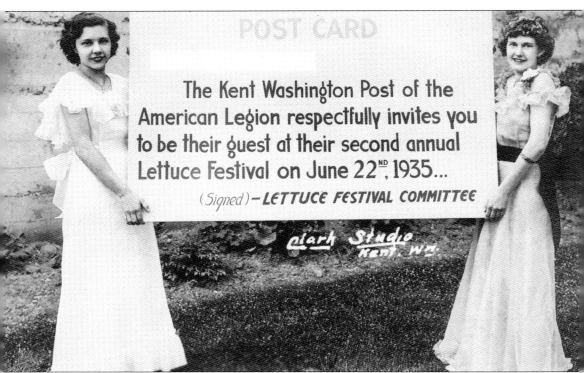

During the 1930s, Kent was considered the Lettuce Capital of Washington State, and the Lettuce Festival Committee wanted to give Kent residents the opportunity to commemorate the event with a giant, personalized postcard. Photographers from Clark Studio would allow guests to hold up the postcard and send their photograph out to their chosen recipient. Placards to attach were offered, with one reading "Mr. President" if patrons chose to invite Franklin Delano Roosevelt to attend festivities. (Courtesy of Greater Kent Historical Society.)

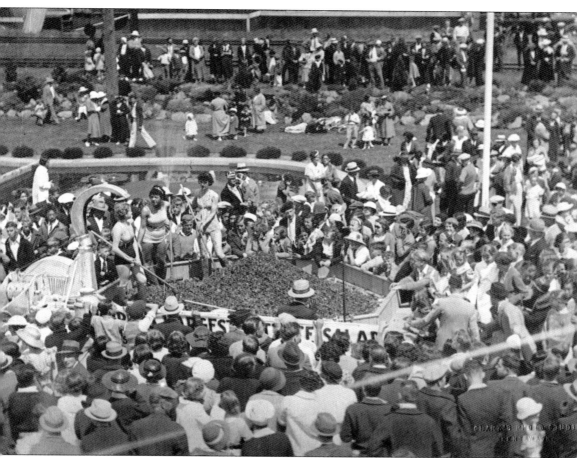

One of the celebrations that occurred during the Lettuce Festival was the World's Largest Salad. The salad itself was served in one of the parks along Railroad Avenue. After the presentation of the Lettuce Court, salad was shredded mechanically and dished out by young women wading through the lettuce wearing rubber boots and serving it with pitchforks. (Courtesy of Greater Kent Historical Society.)

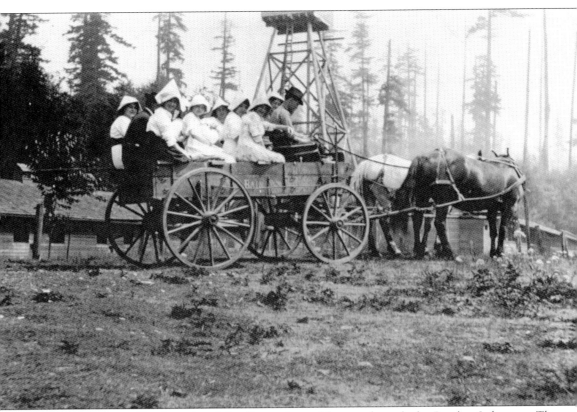

The daughters of local resident John Burnard travel by cart through the Panther Lake area. The girls are headed to the Oliver farm, owned by the family one of the daughters, Ida, married into. Panther Lake is now part of Kent, At the top of East Hill, it was similarly cleared of its lumber to make space for farmland by the small lake. (Courtesy of Greater Kent Historical Society.)

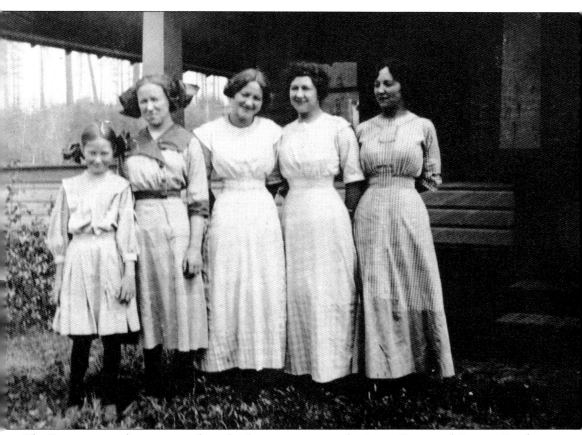

The Rasmussen girls are pictured on the farm, past present-day James Street and Benson Road. Standing from left to right are Helen, Laura, Alma, Mathilda, and Stella. (Courtesy of Greater Kent Historical Society.)

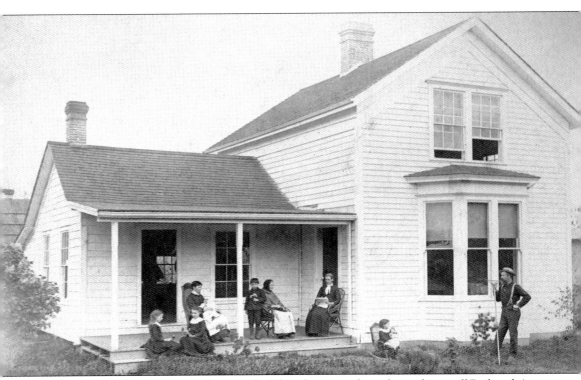

The Ramsay family enjoys a day outside. Their homestead was located just off Railroad Avenue, between Temperance and Kent Station Streets. Robert Ramsay holds the rake, Robert Jr. has the posies, and Eleanor (Nell), Charlotte, Anna, Mary, and baby Harry sit on the porch. (Courtesy of Greater Kent Historical Society.)

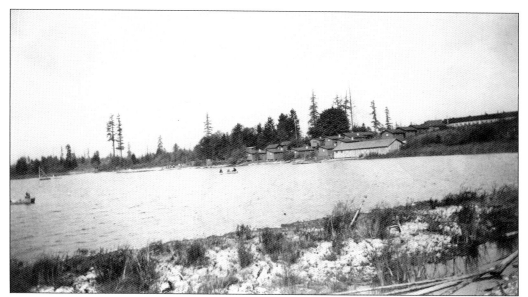

Lake Meridian was a logging camp, then a resort, and after became a public park and residential neighborhood. Here, in 1926, houses were starting to be built around the resort, as it was a popular spot for canoeing and kayaking. (Courtesy of Greater Kent Historical Society.)

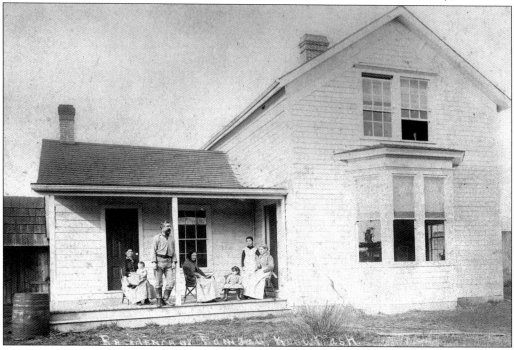

The Ramsay Ranch House was built after the Ramsay family bought 80 acres of farmland in 1877 in the valley below East Hill. The area was a prime location for farming as it bordered the street that would later become Railroad Avenue. Their ranch house was the center of their family life. This land was sold to the Northern Pacific Railroad Company, and the Kent train station and train depots were built less than 100 feet from this spot. (Courtesy of Greater Kent Historical Society.)

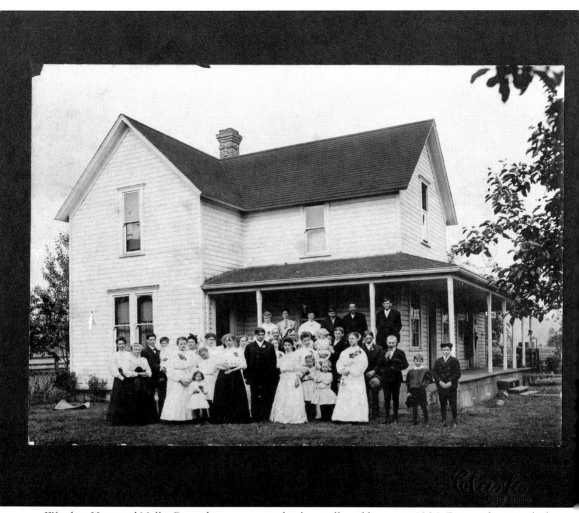

Wardon Hart and Nellie Boundy were married at her girlhood home in 1906. Descendants include one daughter, Fay (Hart) Williams, and her daughter Phyllis (Williams) Urquhart, who was also born in this house. (Courtesy of Greater Kent Historical Society.)

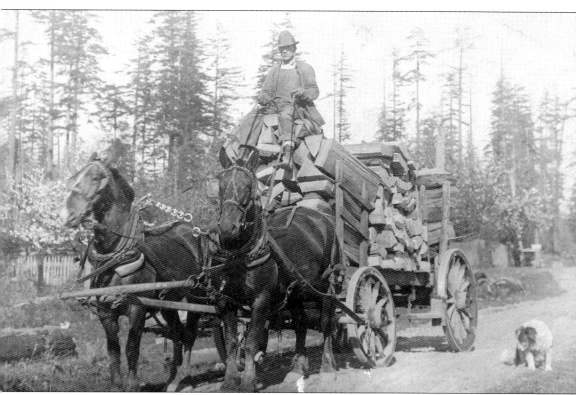

The popular notion of logging has all lumberjacks felling whole trees and sending them downriver in droves, but loggers could work in smaller teams and even individually in some cases. While East Hill did provide a convenient slope for logs to reach the valley, both Green River and Mill Creek were too small and too far south. Rather, the logs were transported down the hill by wagons or skid roads. (Courtesy of Greater Kent Historical Society.)

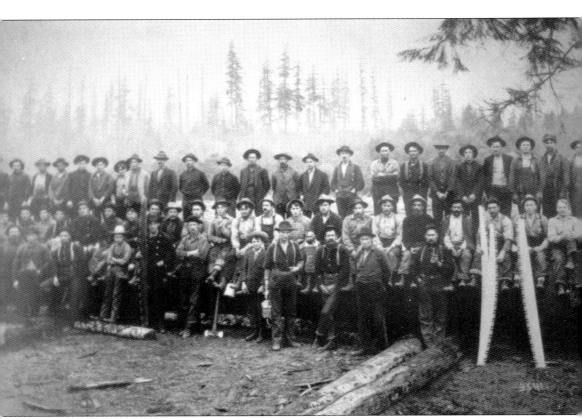

Prior to serving as Kent's mayor, Emil Bereiter was a businessman who owned and operated logging camps on East Hill in the first decade of the 1900s. The red cedar was the best source of building material for the valley, and chopping down trees and rolling them down the hill was a convenient mode of transport. Bereiter made a fortune for himself and his family. Their house, now a preserved landmark, contains the highest quality wood paneling, with no visible knots inside or outside the house. (Courtesy of Greater Kent Historical Society.)

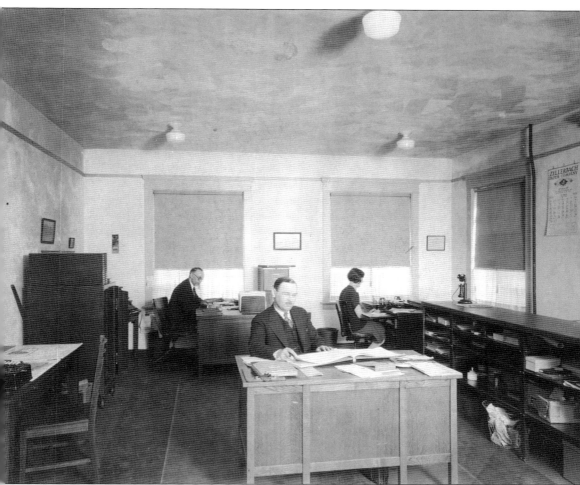

Three employees sit in the interior of the Skookum Chix Kent office. In 1928, Kent was a farming and business hub, and many commercial farming companies were useful for locals keeping up with the latest trends and maintaining healthy livestock. Skookum Chix was a local franchise that sold chicks and provided education to local poultry farmers. Skookum had two offices in Washington and one in Montana and frequently delivered to many farms in the White River Valley. (Courtesy of Greater Kent Historical Society.)

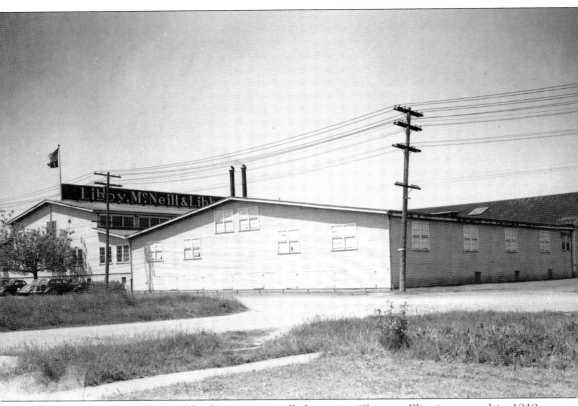

The Libby, McNeill, & Libby factory, originally begun in Chicago, Illinois, opened in 1919 on former Ramsey farmland. The canning company was in an ideal location for Kent residents to work after the fall harvest. Crops could be preserved, canned, and shipped onsite. For 50 years, the factory stood until it moved its headquarters to Oregon. Currently, it exists as an entity of Swift & Company. (Courtesy of Greater Kent Historical Society.)

Three
SCHOOLS

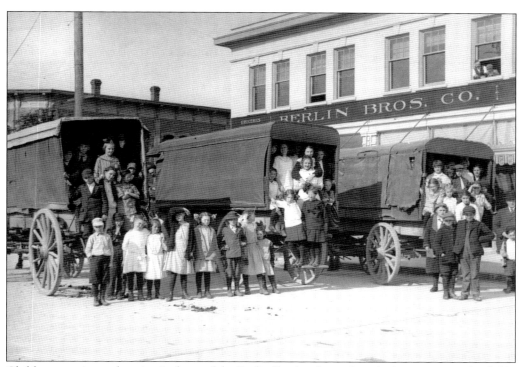

Children are pictured posing in front of the Berlin Brothers' storefront before going to school. Up until 1895, most of the schools in the area only taught to about grade eight. Many of the students were the children of lettuce and hops farmers, so traveling to school would have been a longer trip, especially considering the frequent flooding in the valley prior to the Hanson Dam. Kent was the first city in Washington to offer such a service to its schoolchildren. (Courtesy of Greater Kent Historical Society.)

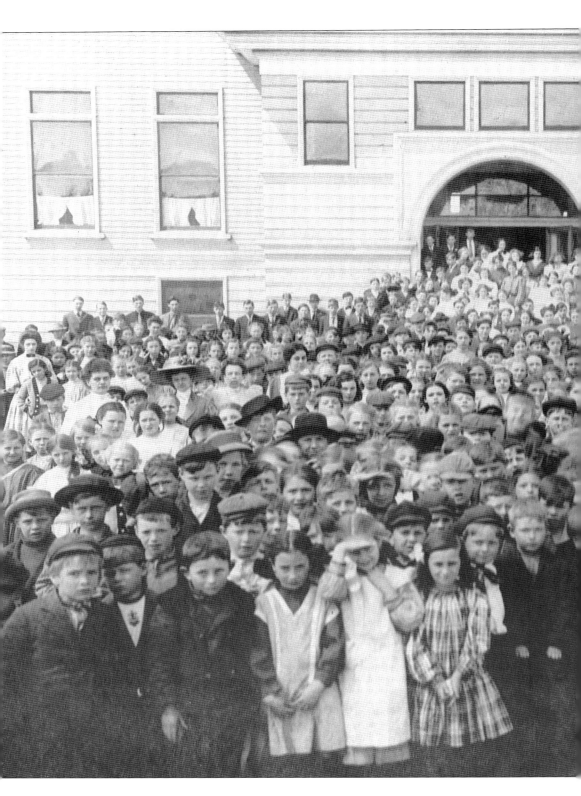

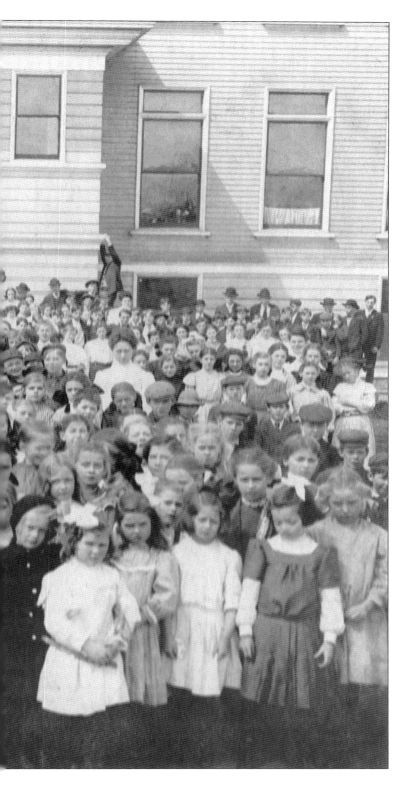

Taken in early 1900, this photograph shows the Kent Elementary School, which had previously been a single school for elementary to high school students, built in 1890, with a staff of 12 teachers. Charles Allen moved from the Dakotas to Kent in 1884, established a night school for older children, and extended the school year to nine months. Professor Allen stands to the right of the door, under the white sign. (Courtesy of Greater Kent Historical Society.)

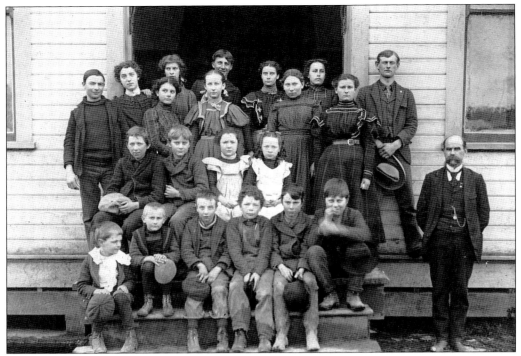

The O'Brien School, also called the Willis School, was much smaller than its Kent counterpart but employed many teachers to suit their students' needs. Lena, Howard, and Kate Burke attended, despite the fact that the family had a house in Kent in 1900. (Courtesy of Greater Kent Historical Society.)

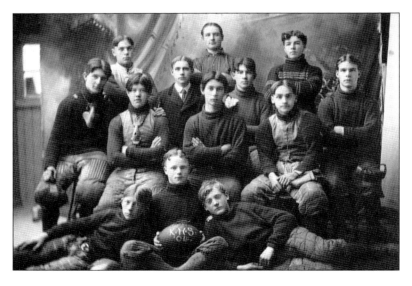

The Kent High School football team posed for this picture in 1904. From left to right are (first row) Tom Barnes, Hans Niessen, and Millard Calhoun; (second row, sitting) Cliff Stuart, Red ?, ? Guibor, ? Pulver, John Stewart, Will Berlin, Heiny, Earl Titus; (third row, standing) Roy Root, Gerald Gannon, and ? Armstrong.

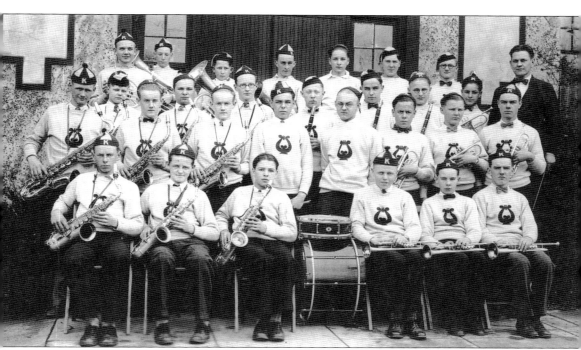

Built in 1908, the former Kent High School sat at the base of Scenic Hill between Kensington Avenue and Titus Street. Here, the 1927 band poses for its yearbook photograph. In the band that year, listed from left to right, were Frank R., Herman Youngman, Forest Rol, Bearge Marsh, Glenn Rohlinger, Jack Sears, Russell Faulkner; Ralph McIntosh, Melvin Marlowe, Robert Kirshner, Louis Becvar, Richard Kirshner, John Owen Taylor, James McCulloch, Ellis Anderson, Sidney Leeper, Hadly Chamberlain, Sandford Sevetson, Bently Saultern, Herbert Baldwin, Shirley Hunt, Harold Roder. Last row: William Timis, Billy Stover, Kenneth Faulkner, and Vincent A. Hiden. (Courtesy of Greater Kent Historical Society.)

Kent High School was located in the White River Valley in 1916 and did not move up the hill until the 1950s. Here, the class seniors pose in front of the Kent Theatre, which had a similar life span to the original high school. The old campus did not have a real stage, so the students performed at the hall of the Independent Order of Odd Fellows. (Courtesy of Greater Kent Historical Society.)

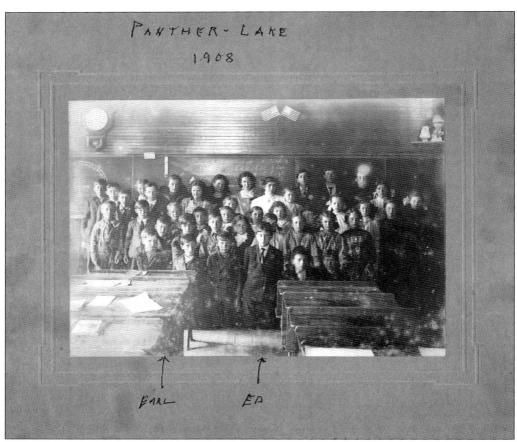

Schools on Kent's East Hill did not always use the traditional grading system now standard for the district. Just before the beginning of World War II, the old grading system was replaced. Previously graded as G (Good), S (Satisfactory), D (Doubtful), and U (Not Passable), students were given marks such as A (Strong), B (Good), C (Satisfactory), D (Doubtful), or E (Not Passable). (Courtesy of Greater Kent Historical Society.)

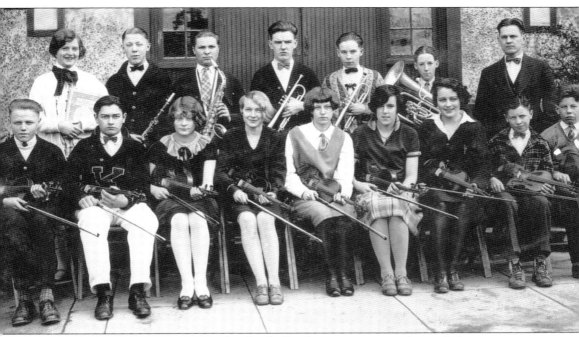

Despite the small class sizes, Kent High School offered many extracurriculars including sports, arts, theater, and music. Multiple activities gave students experience in a variety of different mediums, even if they did not end up going to college or playing music professionally. Louis Becvar, in the second row in the plaid tie, played saxophone but ultimately opened the Kent Flying Service with his brothers. (Courtesy of Greater Kent Historical Society.)

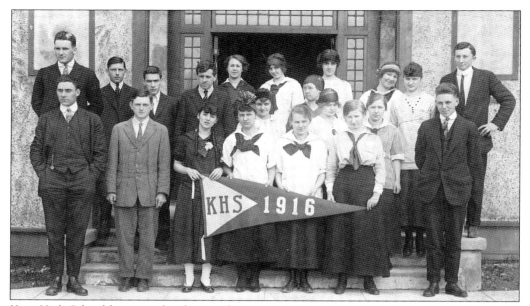

Kent High School began under the jurisdiction of the Kent School District, which in itself only oversaw a few schools both in the valley and on the hill. Class sizes were often small; even with transportation provided, not all students were interested in pursuing education beyond the eighth-grade level. Students who did go to college had opportunities all along Puget Sound. Kent never had a large university, but smaller community colleges like Green River Community College and Highline College opened campuses in Kent later in the 20th century. (Courtesy of Greater Kent Historical Society.)

Early in the 1900s, Kent was expanding into smaller, neighboring settlements previously not considered to be incorporated into King County. Communities like Thomas and Panther Lake had their own schools in their own districts. However, during the 1940s city council began to discuss the possibility of consolidation of Kent, Thomas, O'Brien, Panther Lake, and Meridian School Districts into one entity. (Courtesy of Greater Kent Historical Society.)

Despite the public's initial resistance to the idea, the Kent, Thomas, O'Brien, Panther Lake, and Meridian School Districts began to consolidate in the years following the war. Kent itself had suffered dwindling class sizes following Japanese expulsion, and the new merger also meant that the aging Kent High School could have funds to build a new campus. The deal was finalized as the 1950s began, and the schools were now under the superintendence of the Kent School District. (Courtesy of Greater Kent Historical Society.)

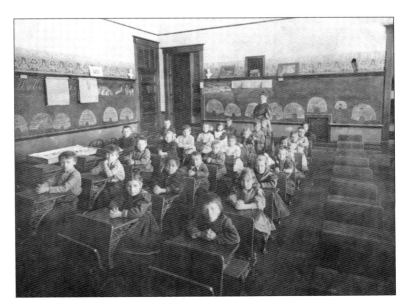

Children attending the Thomas school in 1950 were able to use state-sponsored school buses. Now part of Kent, Thomas is located in the valley north of Auburn. Its school district merged with Kent in 1945, along with other smaller school districts, and newer, larger school buildings were constructed over the years. (Courtesy of Greater Kent Historical Society.)

43

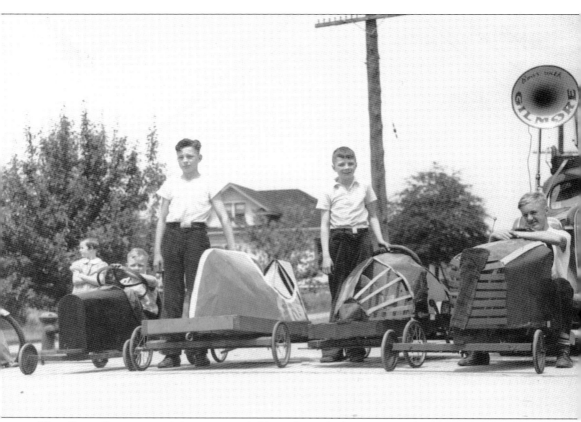

The Great Depression did not stop children from finding ways to have fun. Locals George Hallock Jr., Peter Hallock, and Ronnie Pozzi prepared for a children's derby down Temperance St. on East Hill. The truck overseeing the race belonged to the Gilmore Oil Company, which served Washington, Oregon, and California during the 20th century. (Courtesy of Greater Kent Historical Society.)

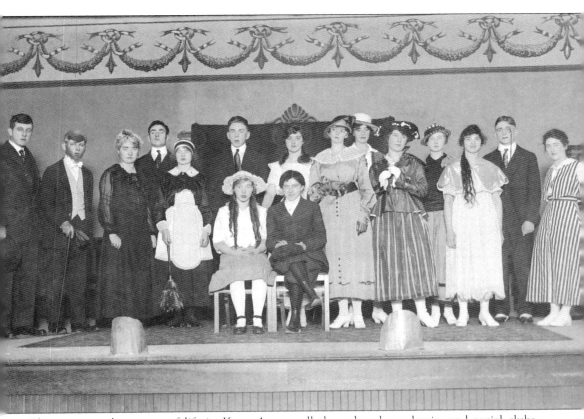

Theater was a large part of life in Kent. Among all the cultural, academic, and social clubs, there were frequent events that the community could attend. This photograph from 1916 was a production of "All on Account of Polly," a vaudeville play, put on by students at the Kent High School old campus in the valley. (Courtesy of Greater Kent Historical Society.)

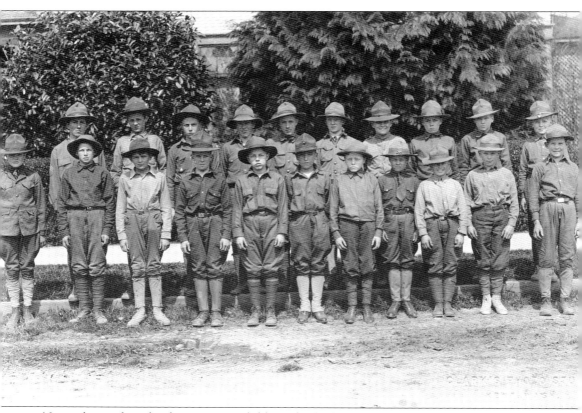

Not to be outdone by their parents, children also had access to a variety of social clubs in the community. One popular club was the Boy Scouts; among other activities, they would also make appearances in school performances, such as 1922's rendition of *The Stolen Flower Queen*. The boys in the troupe that year included Raymond Wrede, Clayton Bierbaum, Benjamin Smith, Charles Warner, John Study, Leslie Swanson, Thomas Hobban, Tom Wooley, Andrew Anderson, Lindon Meredith, Henry Hurst, David Clark, Vernon Stafford, Thomas Morris, Harvey Shaffer, Glenn Rohlinger, Roy Marlowe, Bide Clark, Fred Loventson, and John Anderson. (Courtesy of Greater Kent Historical Society.)

Four
FORMING A COMMUNITY

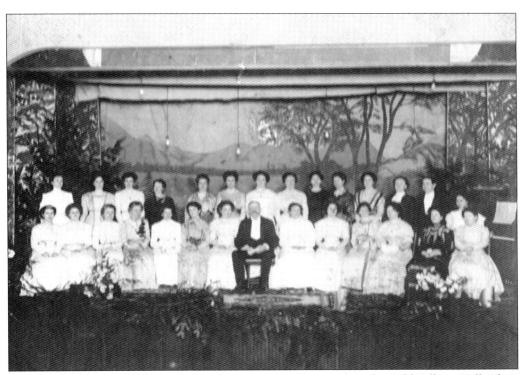

The Women of the Social Society of Kent pose for a photograph at the Odd Fellows Hall. Their members included Marnie Bradley, Mrs. Churchill, Mrs. Svetland, Mrs. How, Mrs. Marcus, Carrie Arney, Jove Hodges, Dora Alvord, Mrs. Buckley, Jerua Boud, Edna James, Jessie Crow, Nana Calhoun, Blanch Hull, Susie Rogers, Mrs. Reynolds, and Troy Coleman. (Courtesy of Greater Kent Historical Society.)

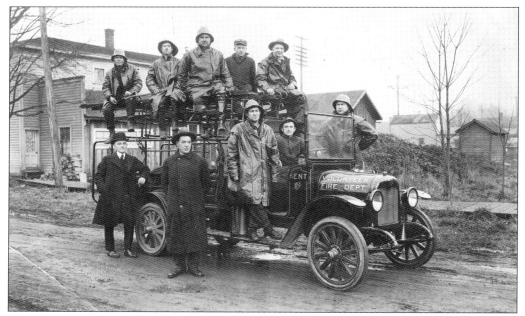

This photograph, taken around 1912, shows Fritz Endman, driver of the volunteer fire truck. He was born on May 9, 1883, immigrated from Germany when he was nine, became a baker in Seattle, and a volunteer firefighter in Kent. He died on July 25, 1973. (Courtesy of Greater Kent Historical Society.)

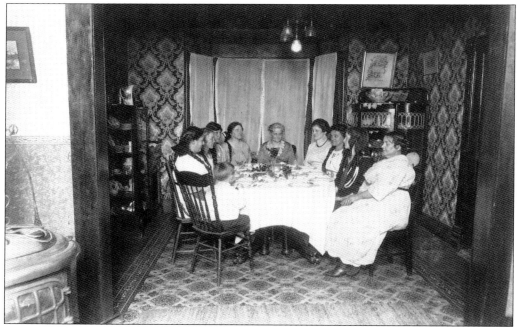

Carrie Reed Arney, far right, hosts a party in her home in November 1921. Invited were Lulla Woodworth, Nellie Ramsey, Kate Snell, Nellie Wood, Lillie Titus Shoff, Maude Cavanaugh, Clara "Cloudy" Nelson, and Bertie Shinn. Lillie Titus Shoff was married to the proprietor of Shoff Store and mother to James and Lester. (Courtesy of Greater Kent Historical Society.)

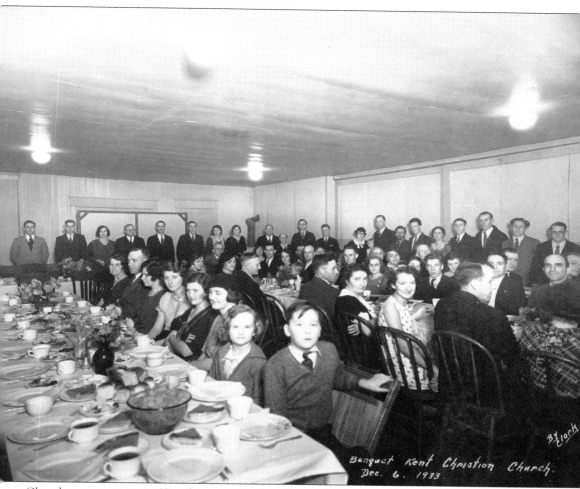

Church communities in Kent began, quite literally, in the home. As settlers were still building both the city and new social circles, they would have church services in homesteads until they could build dedicated chapels. Even after construction, churches would remain a social as well as spiritual function, as dinners and gatherings in church buildings were common. Here, a dinner is held in Kent Christian Church to celebrate Advent. (Courtesy of Greater Kent Historical Society.)

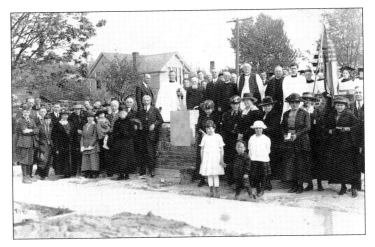

Kent's Christian churches offered a variety of denominations. The St. James Episcopal Church, which has been operating for over 100 years, originated in the valley before moving to East Hill. Pictured here is the laying of the cornerstone for its valley parish in 1921. Many families attended, including the diocese's presiding bishop. (Courtesy of Greater Kent Historical Society.)

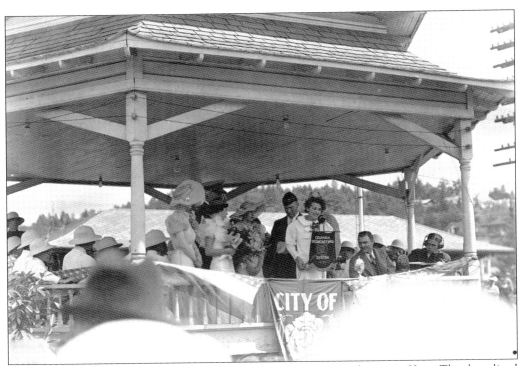

The Presentation of the 1935 Lettuce Queen and Court was a grand event in Kent. The short-lived Kent Lettuce Festival was a citywide celebration of the harvest and local businesses. The streets would be cleared for parades, salads would be eaten, and the royalty would be crowned. The queen of 1935 was Thelma Saito, the stepdaughter of Ernest K. Saito, a Japanese businessman who owned the White River Packing Company. The event that year garnered enough buzz to attract the Columbia Broadcasting System, or CBS News, as it is known today. (Courtesy of Greater Kent Historical Society.)

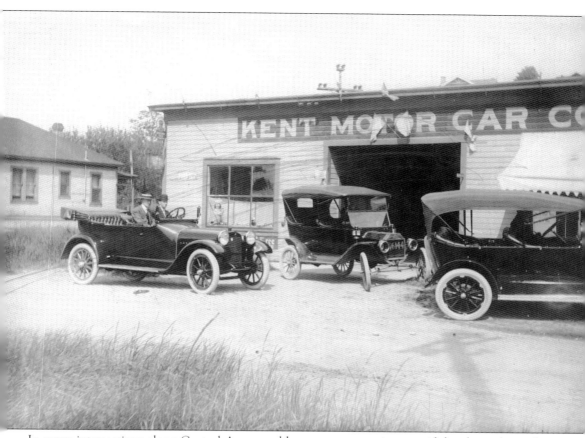

In many intersections along Central Avenue, old car garages remain, even if they have changed ownership over time. Kent's cars have been a business since the early 1900s, and as a result, many motor companies and clubs have had a strong presence here. (Courtesy of Greater Kent Historical Society.)

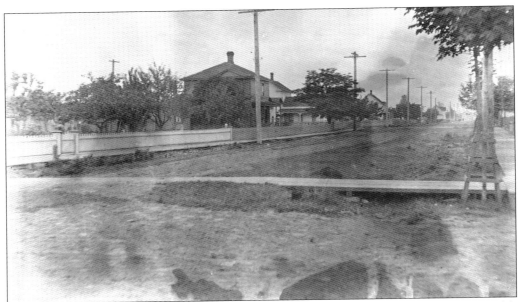

Before the advent of concrete sidewalks, wooden sidewalks were a vast improvement over muddy streets - bringing with them a sense of civilization and permanence to the community. (Courtesy of Greater Kent Historical Society.)

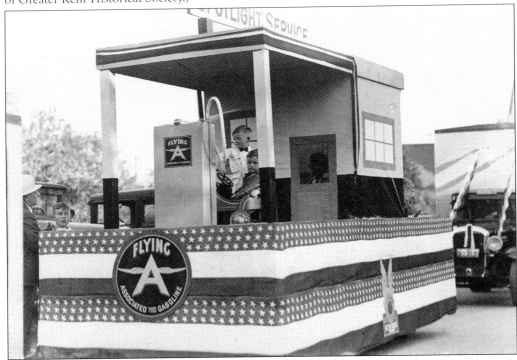

As parades were popular during community celebrations, local businesses used the opportunity to advertise while joining in on the fun. Many decorated their floats with details of what services they could provide; family businesses like Flying A even let their children participate in a scaled-down version of their service station built over their car. (Courtesy of Greater Kent Historical Society.)

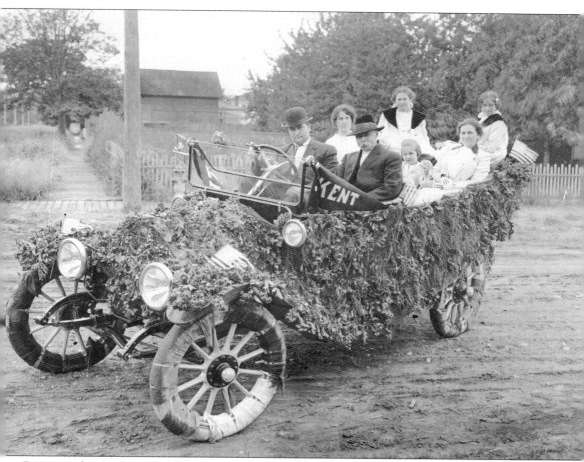

Car ownership in the early 1900s was a luxury, but cars were not an uncommon sight in Kent at that time. Wealthy businessmen could purchase a car and show it off downtown during community events. The Fourth of July parades even included contests for the best-decorated car. The Zeeuw family won in 1910 after decking their convertible automobile in foliage and American flags. (Courtesy of Greater Kent Historical Society.)

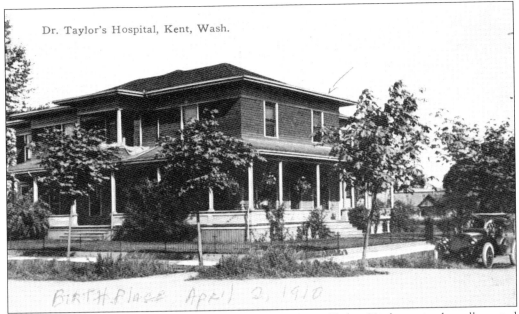

Kent's hospital was also the house of the local doctor, Owen Taylor. His home in the valley acted as an office and surgery, and accounts have been given of deliveries taking place there rather than at home. About three nurses were employed to work for Dr. Taylor at a time, and for a short while, the doctor even kept a pet bear in the front yard. (Courtesy of Greater Kent Historical Society.)

Phone numbers in Kent were once a few digits shorter and included a color and a number following in order to narrow down the groupings. Operators like Gussie Rogers on the far right would act as intermediaries between farms and businesses. After emergency services purchased motorized vehicles, the need for telephones only increased. (Courtesy of Greater Kent Historical Society.)

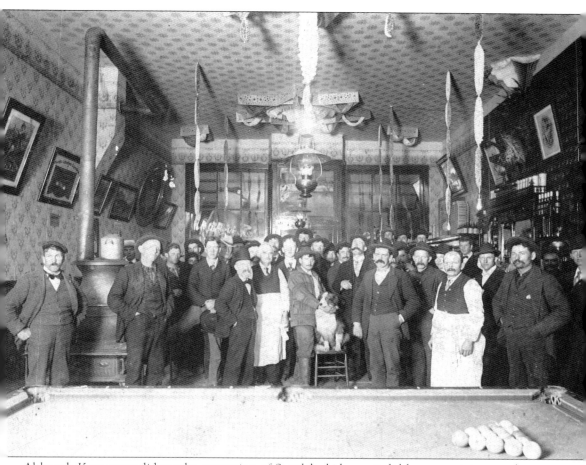

Although Kent never did get the reputation of Seattle's skid row, it did have a certain appeal to both visitors and residents alike as a space for entertainment. Early pioneer settlers tended to live far from one another on farmland, but that did not keep them from interacting and forming a strong community. During the 20th century, many social clubs and groups formed for both men and women. As early as 1895, men would meet their friends at the saloon near the future downtown area. (Courtesy of Greater Kent Historical Society.)

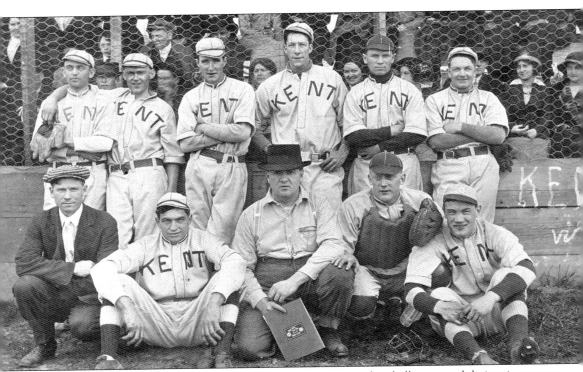

Kent was not the only town in the valley to have a community baseball team, and their primary team pictured here was not the only team that residents could support. Many of the teams were even integrated, having both European and Japanese immigrants play regularly. Games and practices were played on school fields. The White River Valley team, though the reigning champions of the area, used the facilities at the Orillia Grade School. (Courtesy of Greater Kent Historical Society.)

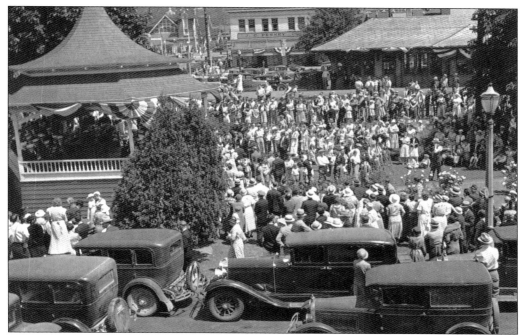

Although many buildings are considered historic, not all were declared landmarks. The bandstand at the forefront has been built and demolished twice and has not been reconstructed since. The historic train station has been relocated twice: once to a temporary location, then back to its original spot as a landmark. J.C. Penney had a long residence in the Berlin Brothers building, but smaller businesses filled the space after 1934. (Courtesy of Greater Kent Historical Society.)

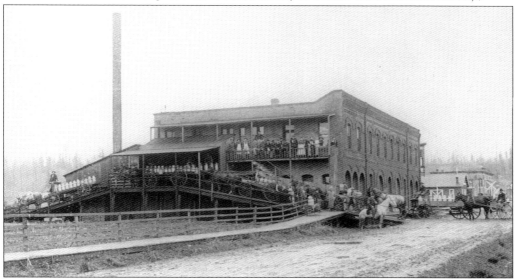

E.A. Stuart bought the first Carnation warehouse in 1899 without a guarantee that milk could be evaporated and shelf-stable. The patent for tin cans was still pending, so cheap imitations were made in-house by hand and not reliable. Early attempts would burst open, yielding spoiled milk that could not be sold. After a few years, the company was nearly bankrupt, but it managed to pull through and became a national brand within 30 years. (Courtesy of Greater Kent Historical Society.)

By 1919, Kent housed major businesses like Carnation and was a major supplier of lettuce to the rest of the state. The one thing it lacked, according to some, was a social scene. In this letter to one of the staff writers at the *Kent Advertiser Journal*, Kent resident and judge R.E. Wooden lamented the lack of options for veterans and young people. Later, Wooden served as mayor at the end of the Depression and the beginning of World War II. (Courtesy of White River Valley Museum.)

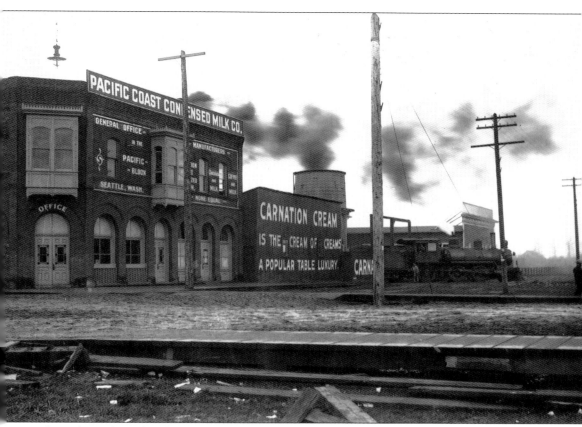

Tracks and wooden sidewalks were located directly outside of the Pacific Coast Condensed Milk Company. Despite its rocky start, Carnation established the headquarters of its now-international enterprise along Railroad Avenue. The milk was delivered from local farms, condensed at the Kent plant, and shipped from the nearby train. Carnation moved its HQ later in the 20th century, and the building has since been torn down with the land developed over. (Courtesy of Greater Kent Historical Society.)

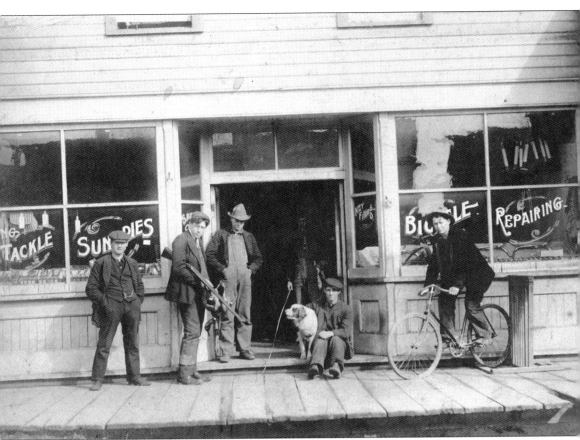

Hunting, though not necessary for subsistence in the 1910s, was a recreational pastime in Kent. Waterfowl like geese and ducks were abundant, and Ben York's bicycle supply store on First Avenue also supplied hunters and fishers with the necessary allocations. (Courtesy of Greater Kent Historical Society.)

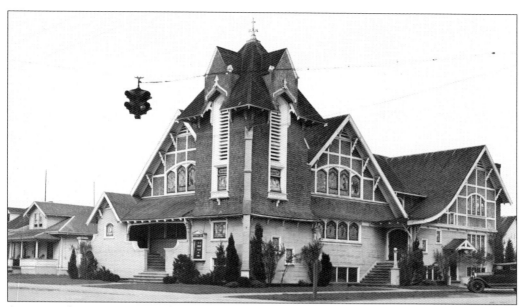

As more ethnic groups moved into Kent, the need for churches to accommodate a variety of denominations arose. The Kent Methodist Church was built on the intersection of Central Avenue and Railroad Avenue, where its tower could be seen easily towering over surrounding buildings. It housed one of the largest Sunday schools in the valley, and even after it was demolished the spire at the top was set aside and preserved; it is now a part of the historical society's collection. (Courtesy of Greater Kent Historical Society.)

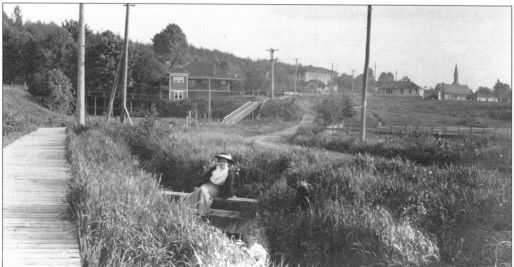

A slope of East Hill just surrounding Mill Creek, just south of downtown, was nicknamed "Scenic Hill" by locals for its views of the valley and Mt. Rainier on clear days. In addition to houses, churches and Kent School were built just above where the worst of the flooding occurred. Even so, wooden sidewalks were constructed in 1910 wide enough that people, horses, and buggies could safely walk from structure to structure without getting stuck in the mud or being swept away after heavy rain raised the creek's water. The area was later turned into a public park, with plans to expand the area even more in the future. (Courtesy of Greater Kent Historical Society.)

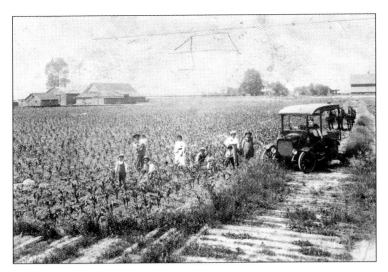

It was not uncommon to see cars share the road with horses, especially around farms in the 1920s. Plank roads were more practical than dirt roads, as they ran fewer risks of getting overrun with vegetation and provided protection from mud. Many farms shared borders, and the plank roads marked a clear boundary between them. (Courtesy of Greater Kent Historical Society.)

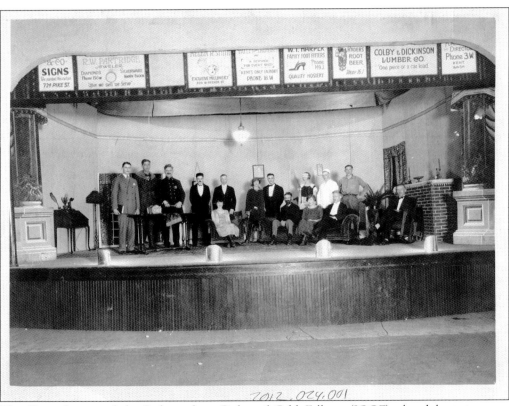

The Kent chapter of the Independent Order of Odd Fellows (IOOF) played host to many community theater productions and even high school shows on occasion. The stage was partly paid for membership dues, but also by advertising rights. Prior to movie theaters and radios at home, advertisements were relegated to newspapers or public spaces. Before a play began, audience members perused the posters of sponsors on the proscenium. (Courtesy of Greater Kent Historical Society.)

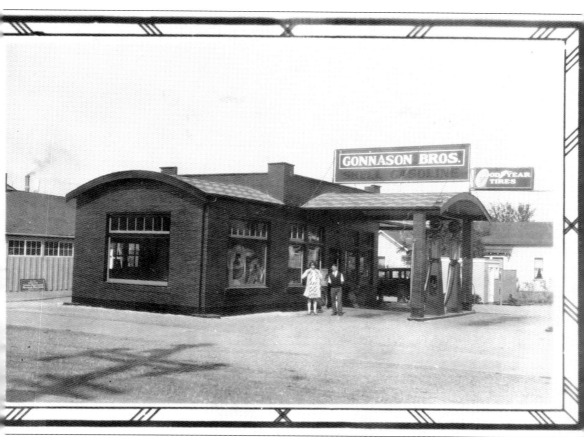

The popularity of automobiles in the 1920s created the need for automobile maintenance, and many service stations opened to serve that role. The Gonnason Brothers was a family-operated service station that could offer fuel and tune-ups. After a few decades, the family closed the station and began selling motorized boats, a business that remains open today across the street from the historic Gonnason building. (Courtesy of Greater Kent Historical Society.)

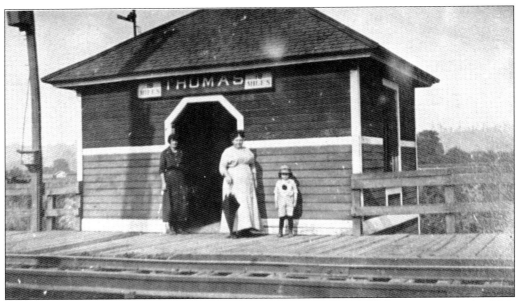

Thomas was a small farming community that was eventually absorbed into Kent in the 20th century. South of Kent, it was close to Auburn and had its own, albeit small stop on the Interurban railroad. Note the wooden overpass built high over the streams that dotted the White River Valley, keeping the tracks and station from being washed out during flooding season. (Courtesy of Greater Kent Historical Society.)

Kent May Become a Part of Greater Seattle

This newspaper article from White River Journal, January 3, 1908 details the possible incorporation of Kent into Seattle, remarking on the recent developments of Kent. Seattle was already making a name for itself as the gateway to Alaska and the Klondike Gold Rush as well as an important port city. Kent may not have been the biggest trade hub at the time, but its proximity to both Seattle and Tacoma meant that it was getting business from both. (Courtesy of Greater Kent Historical Society.)

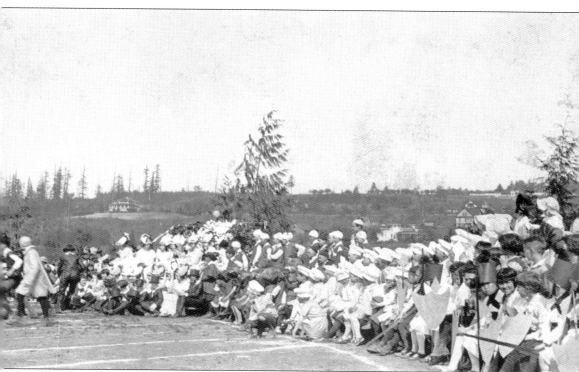

Almost 10 years before Kent had the Lettuce Festival, there was the May Fete. This celebration was held on a much smaller scale and on school playfields. Children dressed in costume, a May Queen was chosen, and games were played. Evidence of the heavy logging can be seen on East Hill behind the bleachers, and the Bereiter mansion can be seen in the middle right. (Courtesy of Greater Kent Historical Society.)

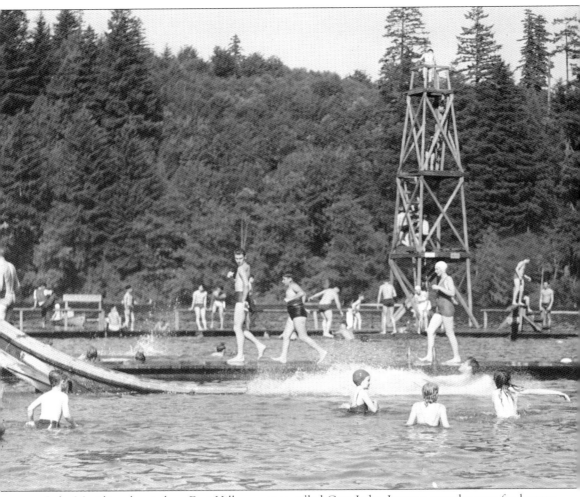

Lake Meridian, located on East Hill, was once called Cow Lake. It was a popular area for loggers as it fed the roots of the wild red cedar trees. Once logging camps moved closer to the valley, Lake Meridian became more of a recreational spot, and a resort was even opened for residents and visitors alike to enjoy water sports like high dives and slides. Parts of the lakeshore are residential, but a public park has been established so that the lake remains a public space for all to enjoy. (Courtesy of Greater Kent Historical Society.)

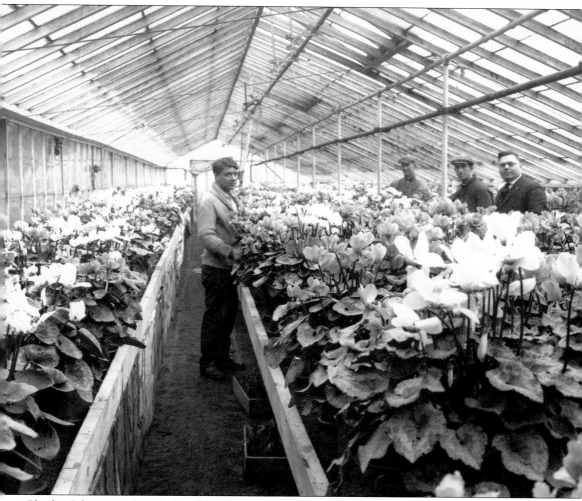
Charlie Gilmer, unidentified, Bill Hawkins, and Geo Rosaia prepare poinsettias for Christmas in 1937. Rosaia was the proprietor of the greenhouse, located in Thomas. (Courtesy of Greater Kent Historical Society.)

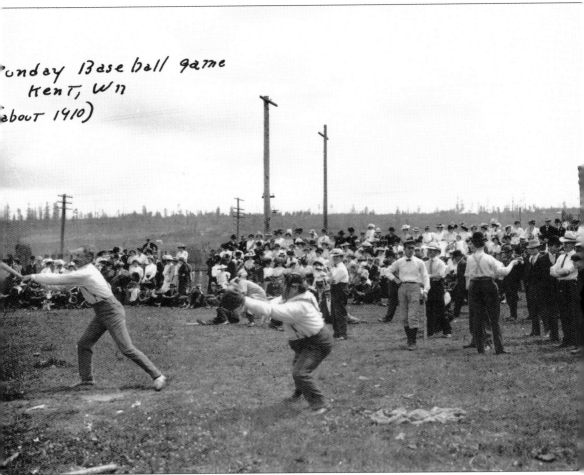

Baseball was considered America's pastime, and Kent was no exception. Regular games were played, and O'Brien, Thomas, and Auburn teams played the Kent baseball team in the 1910s. (Courtesy of Greater Kent Historical Society.)

Five

Trains

Kent has always had strong ties to railway travel. From the interurban to the Northern Pacific Railroad, and Sound Transit, Kent has relied heavily on the trains to move both agricultural goods and people. (Courtesy of Greater Kent Historical Society.)

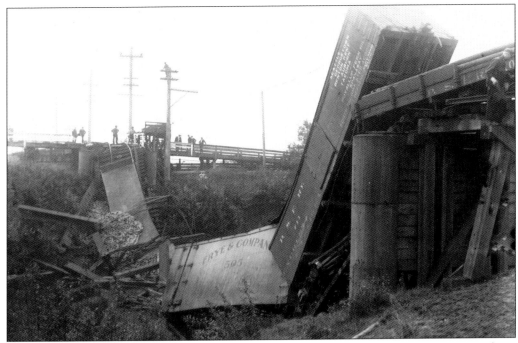

The Kent Interurban was the passenger rail line that could take commuters north to Seattle or south to Tacoma. Beginning service in 1902, it was the only passenger train in the city for the first couple of decades. The tracks' location was the namesake of Railroad Avenue. With unpaved roads and a valley prone to flooding, it was also the fastest mode of transportation between towns. Two rail accidents were photographed along the interurban, but neither deterred engineers and businessmen alike from rebuilding and moving. (Courtesy of Greater Kent Historical Society.)

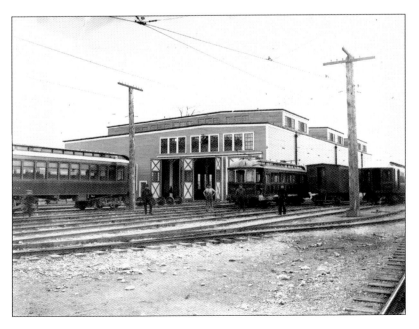

Beginning service in 1900, the Interurban not only brought Kent residents up to Seattle but ran on Seattle cable car tracks to reduce the number of transfers and make the commute easier. There is still train service to Seattle, but commuters have a choice of train or bus. (Courtesy of Greater Kent Historical Society.)

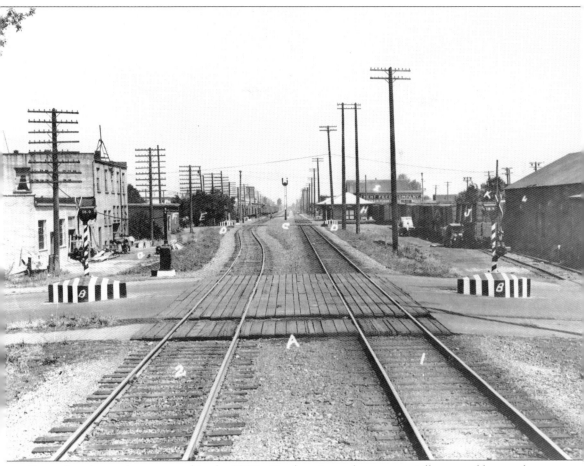
Even after the roads were paved in the 1920s, Kent's train tracks were partially covered by wooden planks to prevent cars and bicycles from getting stuck in the mud. The second building from the left is the Rice Building, formerly the Rice and Coble store. (Courtesy of Greater Kent Historical Society.)

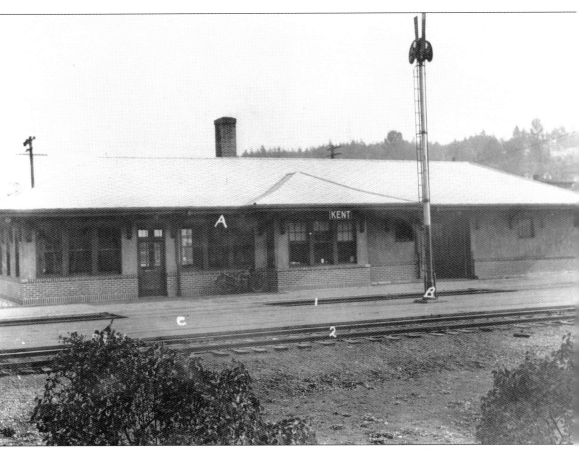
Kent's train station was located on Railroad Avenue between Meeker and Gowe Streets. It was where tickets were sold and the boarding platform was for the Kent Interurban in the 1920s. (Courtesy of Greater Kent Historical Society.)

Six
Downtown Kent

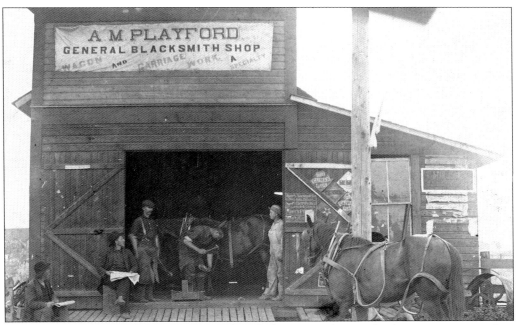

Most of the surviving photographs of Kent's early days were taken in the downtown area or close to the railroad tracks. Kent was settled both in the valley and on the surrounding hills, but there is no question that the valley was where the city's heart was. Life grew there despite the flooding, and most businesses chose to stake their claim where the most people would pass through, such as Alex Playford, center, when he chose to open his blacksmith shop. (Courtesy of Greater Kent Historical Society.)

Descendants of blacksmith Alex Playford brought the family business into the 20th century by opening the Tommy Bow Central Service Station in 1927. Rather than shoe horses, Alex Playford and his mechanics worked on modern transportation as he repaired automobiles. (Courtesy of Greater Kent Historical Society.)

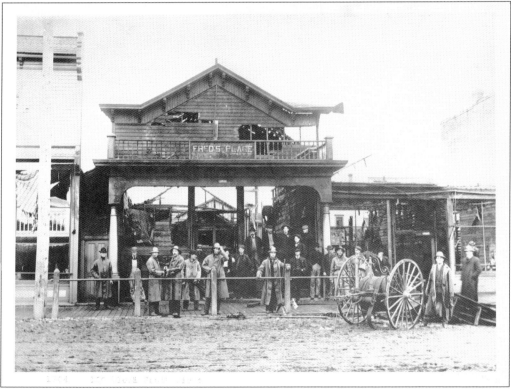

The most notable victim of the July 1904 fire in downtown Kent was Fred's Place Saloon. Despite being less than a mile away from the fire department, the volunteer firemen had to pull the hose wagon themselves and did not make it in time to save the building. The owner, Fred Zebender, did not lose hope and opted to continue selling liquor out of a tent while he rebuilt. (Courtesy of Greater Kent Historical Society.)

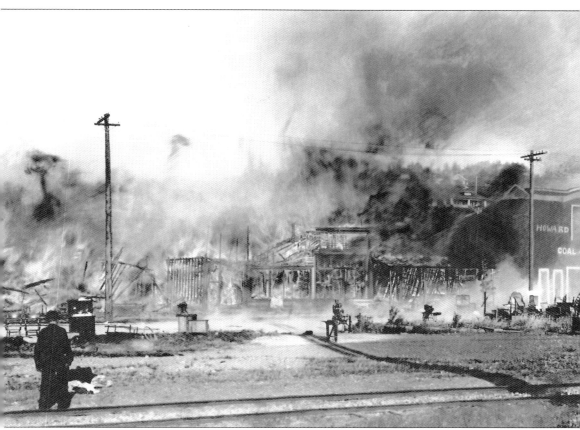

Kent had two major fires during the 1900s. As both East and West Hills were perfect sources of Red Cedar, wood was the most affordable and practical building material. Kent's summers were often dry, meaning the risk of fire was very real. During this fire on July 3, 1914, the entire block of Railroad Avenue and Gowe was razed, although no deaths or significant injuries were recorded. (Courtesy of Greater Kent Historical Society.)

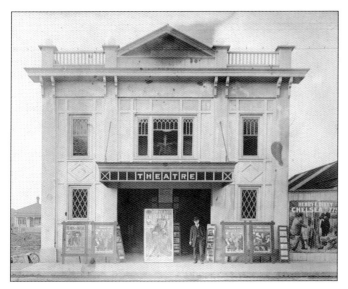

The Kent Theatre was the second theater to open in Kent. Prior to owning this building, A.S. "Pete" Leeper operated the Dream Theatre one block south. The second theater included technology for moving pictures, and a standing organ to play the musical soundtrack by a player pumping the pedals to keep the air moving. Many locals would warn each other not to see films the first day they were released, worried that the organ player would be distracted by the film and neglect their duties. (Courtesy of Greater Kent Historical Society.)

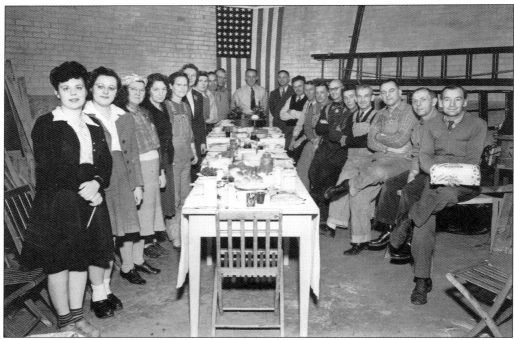

Kent's post office actually predates Washington's statehood. The first official post office building was not built until 1884, but the service had been running since 1860, through the home or business of whoever was serving as postmaster at the time. In 1939, it was moved one block west to its permanent location on Second Avenue. Having a modern location meant that the post office could hire more staff, who pose for a photograph during their staff party here. (Courtesy of Greater Kent Historical Society.)

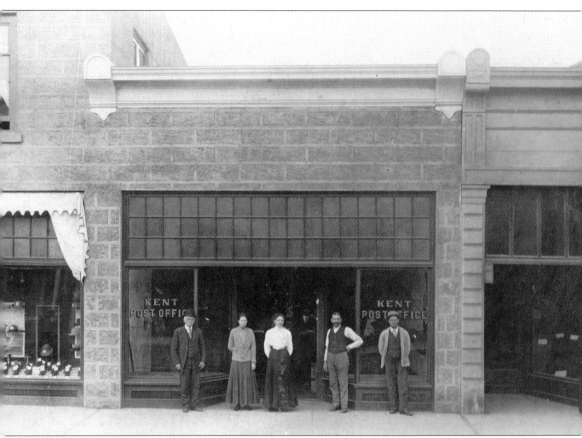

In 1884, the first official post office opened in Kent. No longer running out of the home of the current postmaster, this one shared space on First Ave with the store owned by him instead. In 1920, at the time that the picture was taken, the building that once housed it is now called the Guiberson block, after one of Kent's most prominent families. One of the early post office employees, Nell Woods, in the white blouse, later married into the Guiberson family. (Courtesy of Greater Kent Historical Society.)

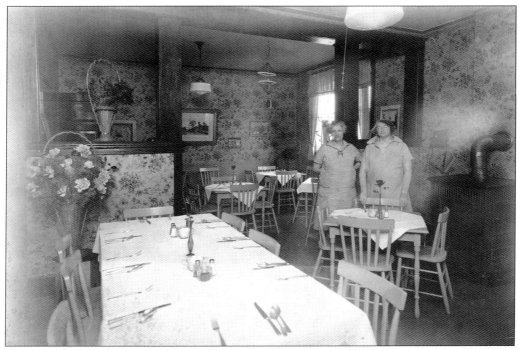

Years after her employment with the post office, Nell Guiberson, nee Woods, opened a tea room in the same building. Her restaurant was on the second floor, where she would have had an excellent view of Railroad Avenue one block west. (Courtesy of Greater Kent Historical Society.)

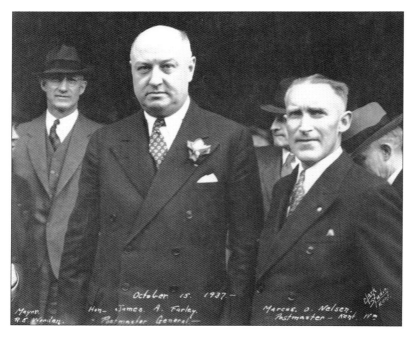

In 1937, Kent received a visit from the postmaster general of the United States, James Farley. His guide for the visit was Kent's own postmaster, Marcus O. Nelsen, and Mayor Richard E. Wooden. (Courtesy of Greater Kent Historical Society.)

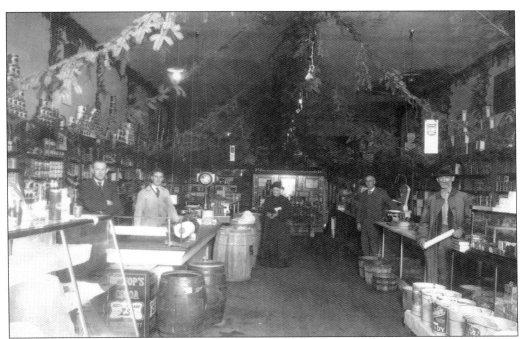

The Kent Trading Company was one of the family-owned grocery stores in downtown Kent; it was well situated on Railroad Avenue, close enough to load and unload merchandise only a block away from the depot. M.T. Ryerson, the owner, stands at the far left. His clerk, Omey Boyker, poses next to him at the register. This photograph was taken after the Christmas decorations were put up in 1914. (Courtesy of Greater Kent Historical Society.)

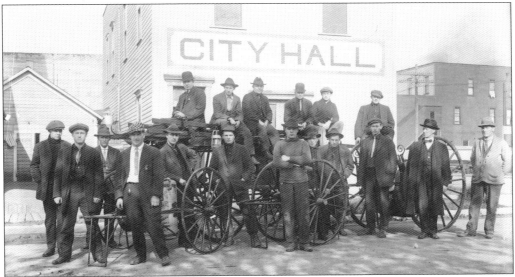

Both Kent's first and second iterations of the city hall shared their buildings with other public services. Its first building had its name painted along the side and a large chimney easy to see from far away. The fire department was made up of volunteers who stored their hose wagons in the space. It was not until the third city hall was erected that the fire department had its own building. (Courtesy of Greater Kent Historical Society.)

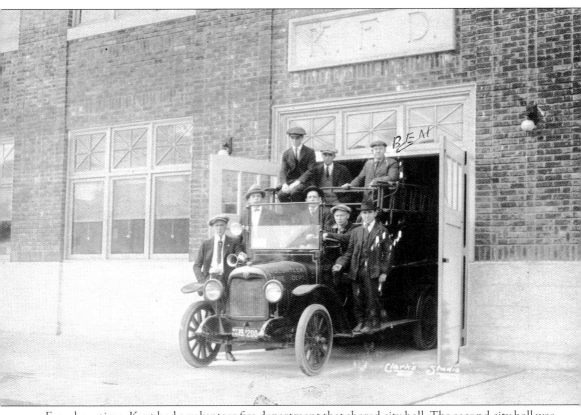

For a long time, Kent had a volunteer fire department that shared city hall. The second city hall was built in 1924 and like its predecessor, had allotted space for the Kent Volunteer Fire Department (KVFD). The first vehicles used were small carts with hose attachments that the firemen themselves would pull to the fire. Two years after the new city hall was built, the department was officially given a motorized fire wagon. (Courtesy of Greater Kent Historical Society.)

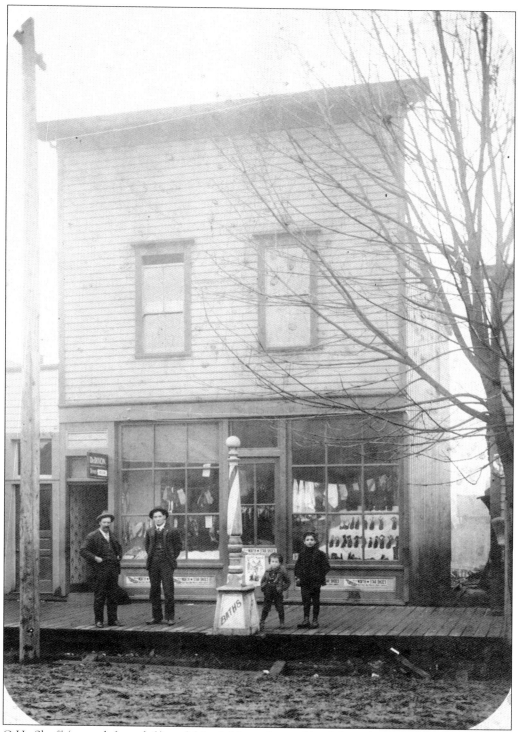

C.H. Shoff (second from left) and his children, James (third from left) and Lester (far right), pose with Homer Meyer (far left) in front of the Shoff Store in 1903. The store was built on First Avenue. (Courtesy of Greater Kent Historical Society.)

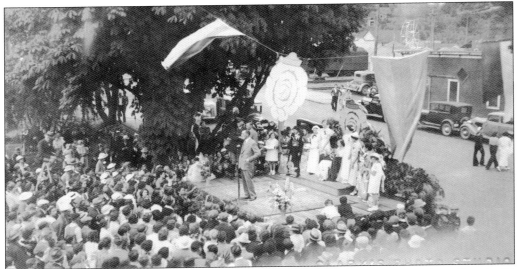

Despite the rapid building up of the downtown area, some small corners near the railroads did remain open-air spaces. In this case, such spaces could be used for community events such as the Lettuce Festival of 1936. The presentation of the Lettuce Queen and her court took place at the corner of First Avenue and Titus Street, currently the Titus Railroad Park. (Courtesy of Greater Kent Historical Society.)

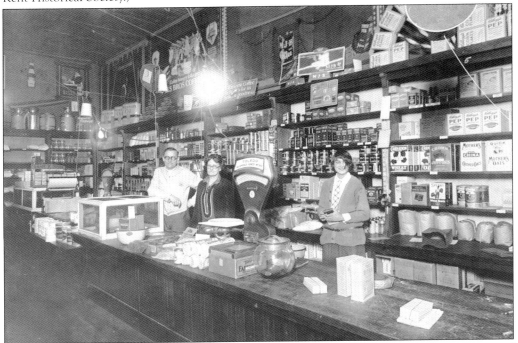

The Grange Warehouse on Smith Street was a collaborative business that grew from a group of Kent farmers who wanted a reliable buying agency. Funded by many, it was originally built in Covington and then moved to Kent in 1912 so that it was closer to the farmlands. Four years later, the venture expanded into a feed store across the street. Even after the warehouse closed, the structures they built remained in use. (Courtesy of Greater Kent Historical Society.)

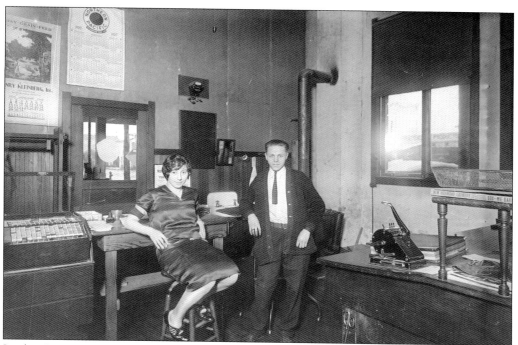

In the Grange Warehouse, Lizzie Matson and Glen Rohlinger relax in the backroom between ringing up customers. (Courtesy of Greater Kent Historical Society.)

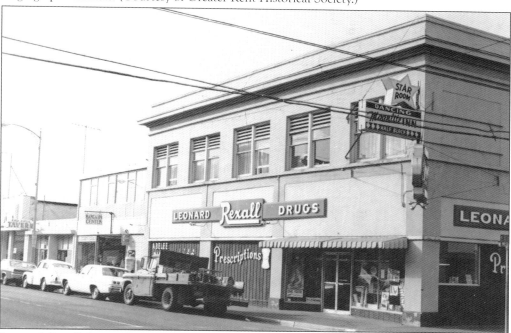

Leonard Rexall Drugs, located at the northwest corner of Meeker Street and Second Avenue, was one of the many family-owned pharmacies in the valley. After its tenure ended, the building later hosted the first offices of the Kent Historical Society in 1992 until the move to the Bereiter mansion in 1996. (Courtesy of Greater Kent Historical Society.)

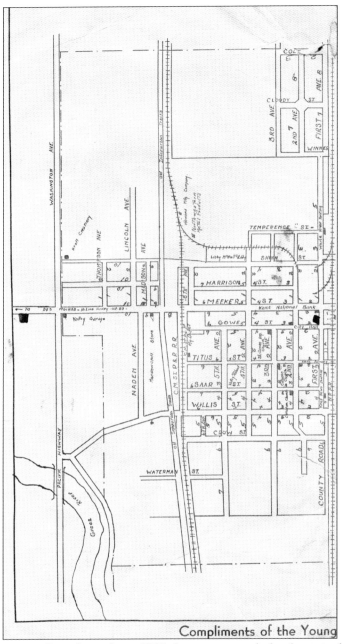

This map is downtown Kent from about 1950. It was a major hub of activity before and after Washington gained statehood. Because of the frequent rain, the valley could sustain farms for lettuce, hops, and berries. Once rail lines were built, it was a convenient way to ship goods to other cities, including Seattle and its ports. When choosing the site for their new venture, the founders of the Carnation Milk Company (then called the Pacific Coast Condensed Milk Company) bought a plant on First Avenue and used that space as their base of operations. Currently, Downtown Kent is viewed as both the historic district south of Smith Street and Kent Station and Kent Commons to the north. (Courtesy of Greater Kent Historical Society.)

Kent police were hard at work in the 1920s—and not only in arresting bootleggers and confiscating distillery equipment. Multiple reports in local papers and police blotters cited stories of thieves stealing tires, hops, money, and even flocks of chickens from local businesses. (Courtesy of Greater Kent Historical Society.)

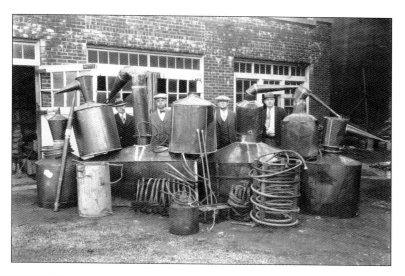

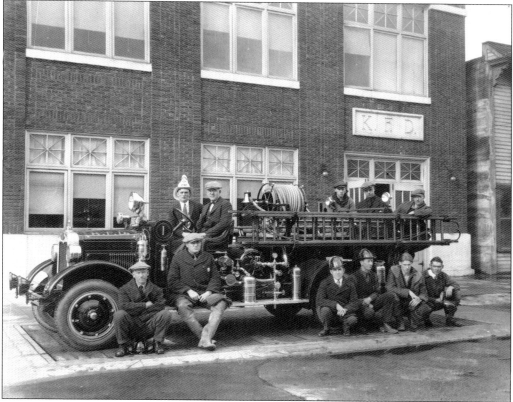

The volunteer fire department was given their hose wagon toward the end of the 1920s, meaning that they not only did not have to pull their own hose, but they could travel farther in a shorter amount of time. Not long after, they began to purchase medical equipment and act as medical technicians as well as firefighters. Here, they pose with their new engine. Second from the right is Duffy Armstrong, who later became a pilot for the Kent Flying Service. (Courtesy of Greater Kent Historical Society.)

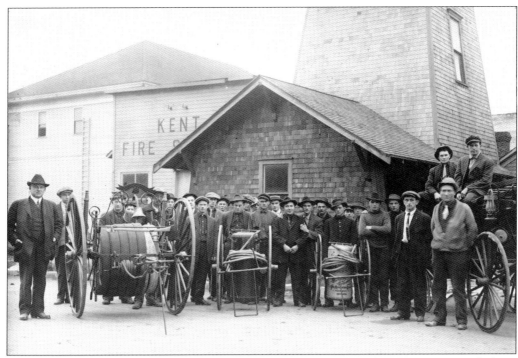

Not everyone had telephones in their homes in 1912, so the fire department averaged about three to four calls a year. Despite that, 27 men volunteered to assist. Pictured from left to right are Tony Coleman, Fred Brotchi, Tom O'Brien, Henry Lobdell, Ford Flaherty, Ben York, Walt Taylor, Hi Reynolds, Chris Campbell, Earl York, Herman Reiten, Huck Holmes, Fritz Erdman, Ollie Cavanaugh, and Rags Meredith. (Courtesy of Greater Kent Historical Society.)

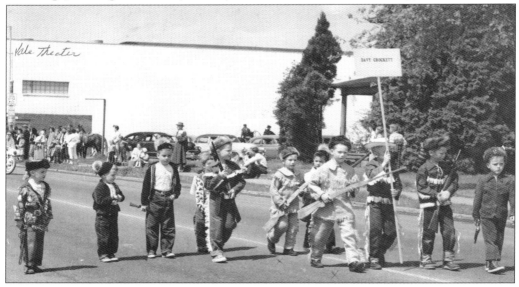

The 1955 film *Davy Crockett* was formative for young children all over the nation. Kent children, such as David and Dick Bosshart, led their friends in dressing as their titular hero and marching in the Cornucopia Parade later that year. (Courtesy of Greater Kent Historical Society.)

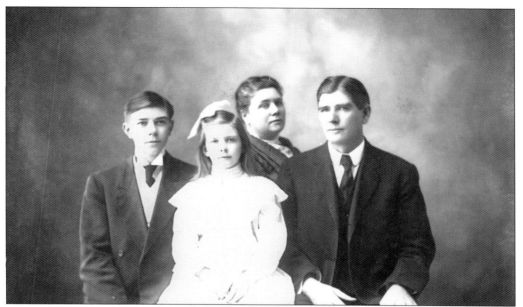

Charlie Guiberson, right, moved to Washington in the 1880s. After finding gold in the Klondike, he built the Guiberson building in 1907 and worked in real estate. (Courtesy of Greater Kent Historical Society.)

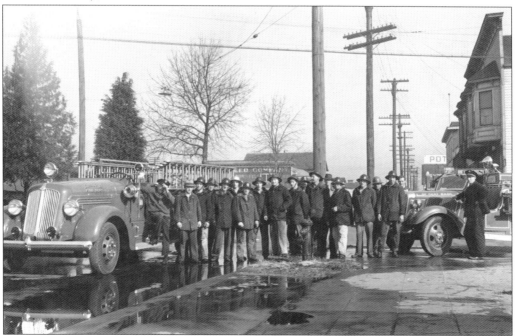

By the 1930s, Kent's downtown had paved roads for cars and buggies alike. As concrete did not absorb the water the dirt roads did, it was far more stable for drivers, especially the volunteer fire department, who served not only Kent residents, but O'Brien residents as well. Phones were more common in households by this time, so emergencies like fires were reported much faster and more accidents could be dealt with. (Courtesy of Greater Kent Historical Society.)

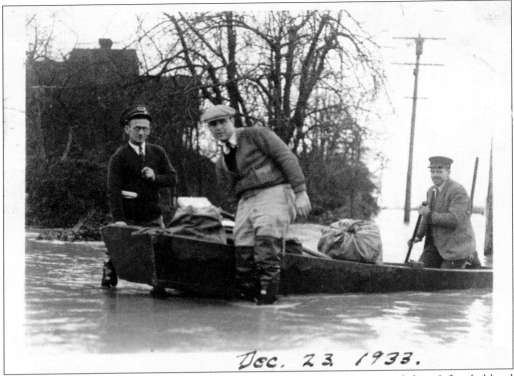

Prior to white pioneers settling in the valley, the native Duwamish navigated the oft-flooded land by canoe. This proved to be the most effective mode of transportation during the rainy months for many residents and visitors alike. The Kent mail service did not forsake its duties for inclement weather, accepting help from generous locals. Here, they assist local mailman Crosby in completing his rounds. (Courtesy of Greater Kent Historical Society.)

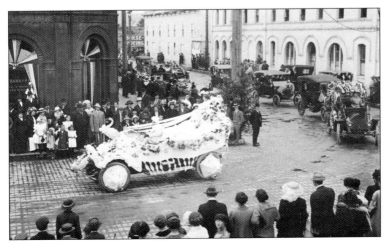

Parades were a common source of entertainment and a chance to celebrate civic pride. Like most Fourth of July parades, this one passing by the Morrill Bank and the Carnation Building is notable for the bunting in every window. Car decorations for parades had begun as early as 1910. (Courtesy of Greater Kent Historical Society.)

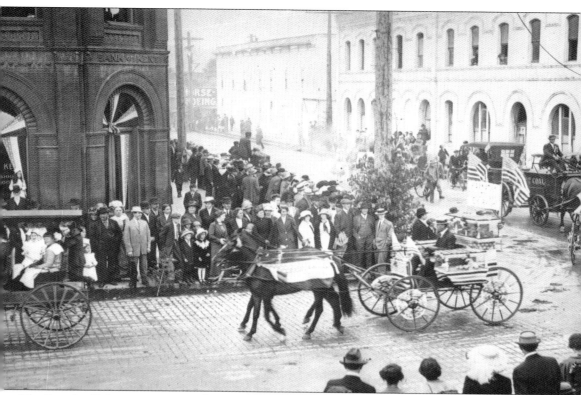

The Fourth of July was an occasion for a patriotic parade in downtown Kent, here at the intersection of First Avenue and Meeker Street. Given the few automobiles in this photograph, it probably occurred before 1910. (Courtesy of Greater Kent Historical Society.)

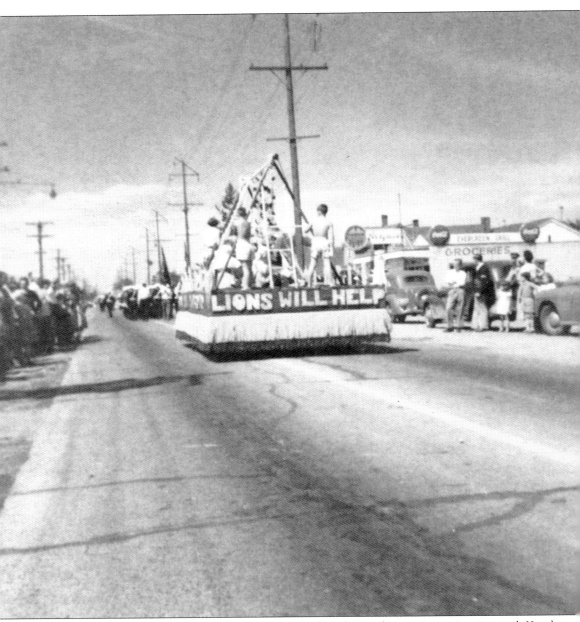

The Kent Lions Parade float joined many Kent parades often with a service project in mind. Kent's chapter was founded in the early 20th century and quickly became integral to the community. Their projects included public infrastructure and providing scholarships to local students to attend college. The fundraiser featured in this parade was a campaign to raise money for a new playground. (Courtesy of Greater Kent Historical Society.)

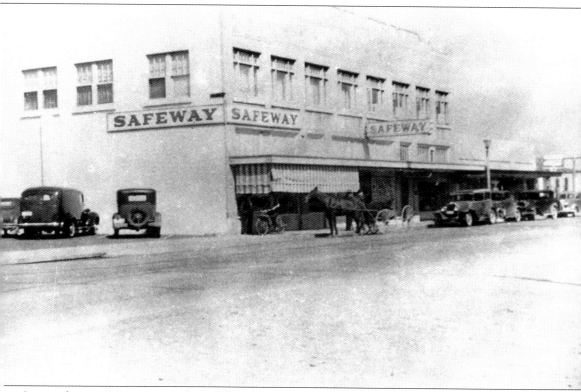

Larger chain grocery stores such as Safeway grew in popularity between the wars. During World War II, it was one of the most advertised for families to spend their ration coupons. This branch was located at the intersection of Central Avenue and Gowe Street, a good location for those who lived in the valley and on the hill. (Courtesy of Greater Kent Historical Society.)

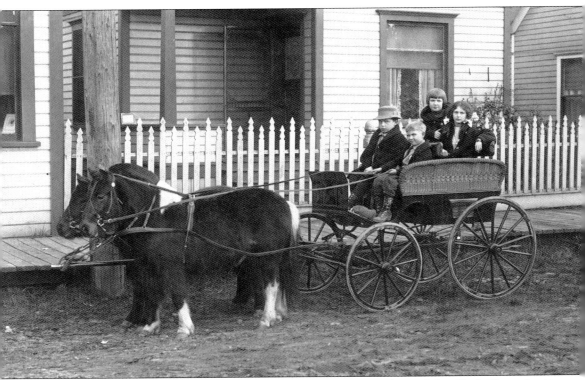

Many photographs taken in Kent were taken by the photographers of the Clark Photo Studio. The studio, owned by Irving Clark, was operated out of his home in the valley. A vital part of the community, almost everyone went to Clark for professional and personal portraits. Here, children pose outside the studio in a small family carriage. (Courtesy of Greater Kent Historical Society.)

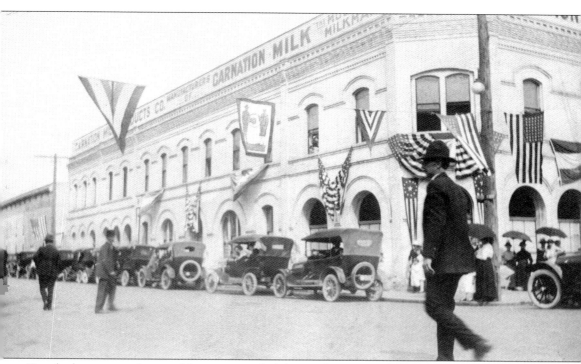

Kent had many parades to celebrate various holidays and events, and they were a draw to out-of-town visitors as well as residents. Many of the photographs taken in Kent and either kept as family heirlooms or donated to historical societies feature at least one parade. Settlers decorated the streets, local businesses put out banners, and cars lined the unpaved streets to observe the May fete, Lettuce Festivals, or Fourth of July celebrations. (Courtesy of Greater Kent Historical Society.)

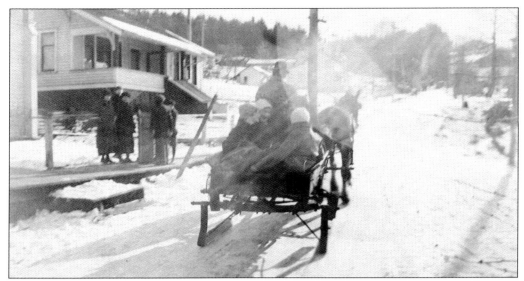

Harmon Rice, proprietor of the Rice and Coble grocery, drives a sleigh through the snowy streets of downtown; his daughter Grace and her friends Ruth Bassett and Beatrice Hatt sit in the back. Snow was not common in Kent, so the rare occasions it did were not to be wasted. Many residents of the valley traveled up to the top of East Hill to ice skate on frozen lakes, such as Meridian. (Courtesy of Greater Kent Historical Society.)

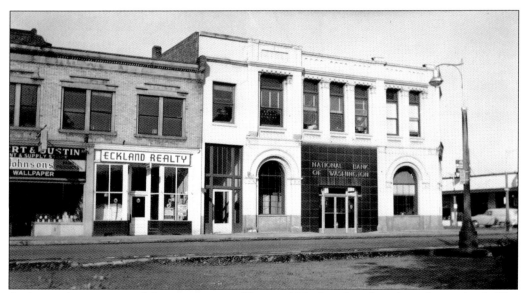

At the southeast corner of the intersection of First and Meeker, there has always been a bank. The first iteration was the Morrill Bank, followed by the National Bank of Washington. Both used the same two-story building, but it was demolished later when the land was purchased by Wells Fargo, who razed the block to accommodate a back with a drive-through and a parking lot. (Courtesy of Greater Kent Historical Society.)

After Carnation left Kent, the plant was demolished and rebuilt. Rather than erase the significance of the site, the new building in its place was dubbed the Kent Creamery, with its name painted on the corner. Smaller businesses filled the space, and downtown became a place for recreation as well as labor. (Courtesy of Greater Kent Historical Society.)

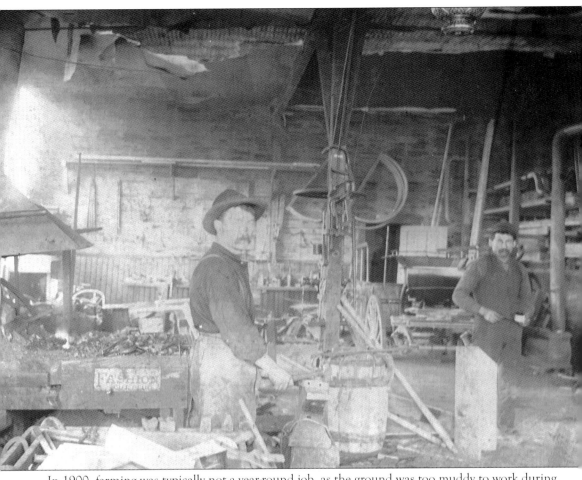

In 1900, farming was typically not a year-round job, as the ground was too muddy to work during the winter. Farmers like Rasmussen, left, often had other smaller business ventures they could turn to, like his blacksmithing shop on the corner of Meeker Street and Second Avenue. (Courtesy of Greater Kent Historical Society.)

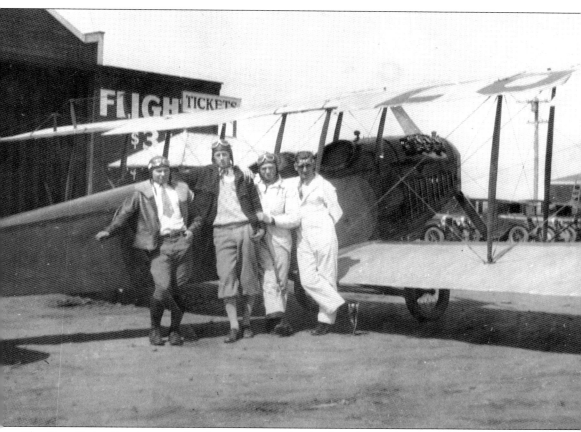

The Kent Flying Service was a local company run by the three Becvar brothers: George, Chuck, Louis, and their friend Duffy Armstrong. After a commercial flight over the Puget Sound in Seattle, the four friends became determined to start their own company. After George and Chuck earned their pilot's licenses in a school in Portland, they bought a plane and opened a business in 1928. Later, all three brothers and their father went on to work at Boeing during World War II. (Courtesy of Greater Kent Historical Society.)

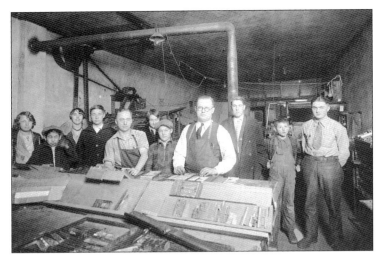

The Kent Flying Service was a small family business offering rides in their Curtiss JN4D (or "Jenny," as the brothers called her) for $3 a ride and even offered lessons to those who wanted to learn to fly themselves in 1929. The endeavor closed in 1931, despite George Becvar working an additional job at the *Kent News Journal* to support the business. (Courtesy of Greater Kent Historical Society.)

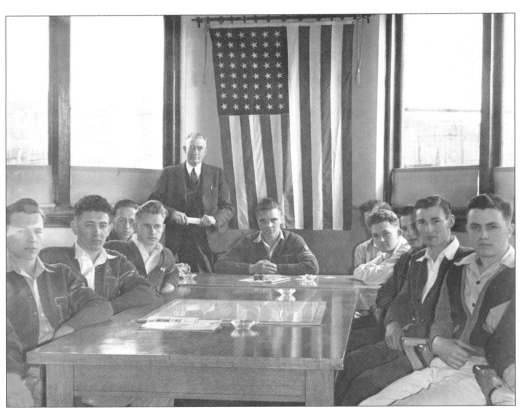

Mayor Richard E. Wooden was a huge proponent of community organization for Kent's youth. After World War I, he felt that the city lacked opportunities for young people to engage in fulfilling and contributing roles outside of school and work. In this photograph, he stands with local high schoolers for a "Mayor for a Day" excursion, allowing the boys to immerse themselves in local government and feel optimistic about their futures. (Courtesy of Greater Kent Historical Society.)

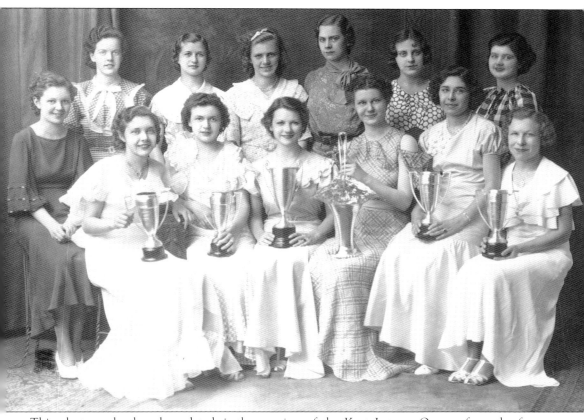

This photograph, though undated, is the reunion of the Kent Lettuce Queens from the four years of Lettuce Festivals, including Virginia Smith (1934) and June Miller (1937) in the first row. Although the date is not recorded, it was likely between 1937 and 1942. Thelma Saito, queen in 1935, left Washington when her stepfather was deported following Japanese expulsion. (Courtesy of Greater Kent Historical Society.)

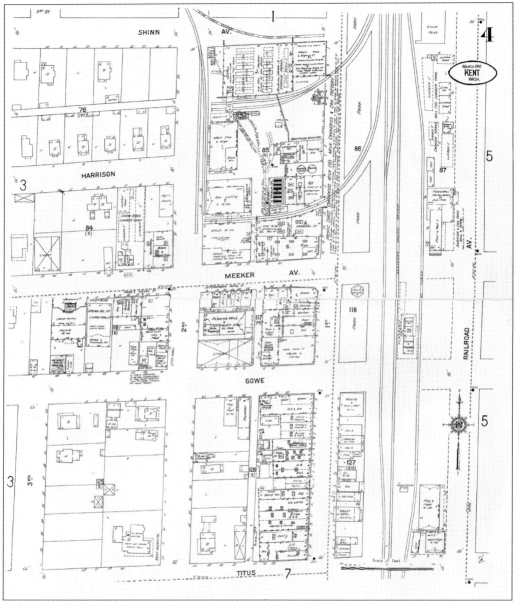

Before Kent's downtown became Kent Station and Historic District, it was a hub of farm-related businesses in 1910. Larger companies like Carnation or Libby, McNeill, & Libby even installed tracks outside of their facilities to better ship their products on the commercial railway. Cars could pull right up to the loading docks and be pushed out to couple with the steam engine easily. (Courtesy of Greater Kent Historical Society.)

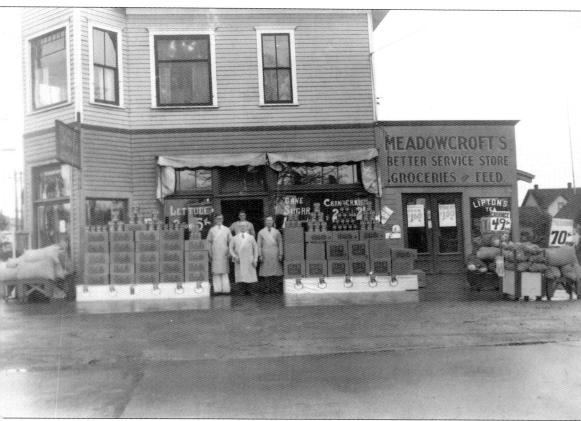

The employees of Meadowcrofts Groceries stand in front of the store and the newly paved roads. The store was a bit further from downtown on Meeker, about halfway between East and West Hills. (Courtesy of Greater Kent Historical Society.)

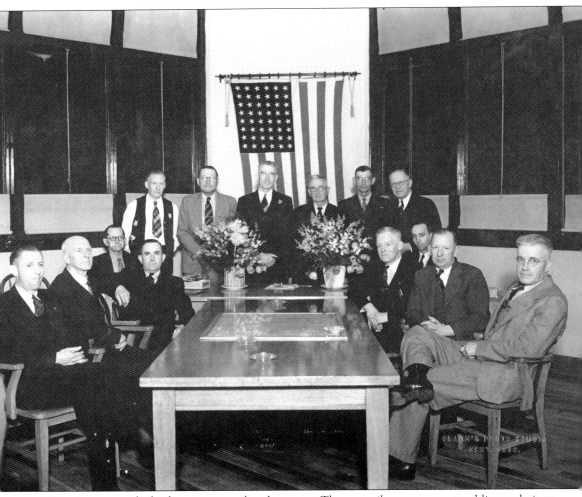

Kent is overseen by both a city council and a mayor. The council oversees most public regulations, while the mayor is considered the chief executive officer of the city. In 1940, the men elected to the city council were made up of businessmen and engineers. Richard Wooden, the mayor, formerly served as a judge. Like current policy, men were elected, not appointed to their positions. (Courtesy of Greater Kent Historical Society.)

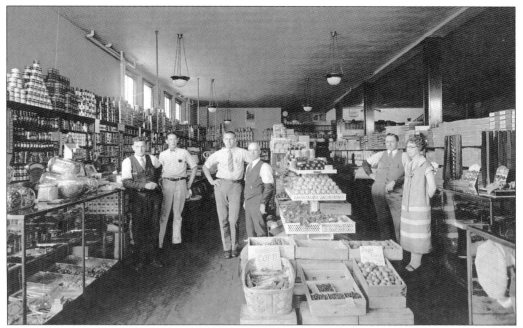

One of the more long-standing businesses in downtown Kent was the Berlin Bros. general goods store. They were located on the east side of Railroad Avenue and as such had a good location to receive consumer goods as they arrived by train. The family ran the store for at least two generations and advertised quite often in both the *Kent Advertiser Journal* and the *Kent News Journal*. As prominent citizens, their activities would often be recorded in the social sections of the *Advertiser*. (Courtesy of Greater Kent Historical Society.)

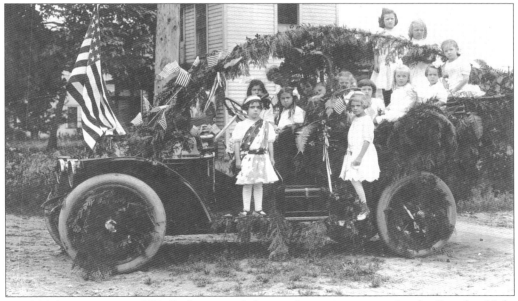

In 1914, business owner T.N. Berlin entered the car decorating contest for the Fourth of July, draping foliage over his truck and allowing local children to ride in the back seats. (Courtesy of Greater Kent Historical Society.)

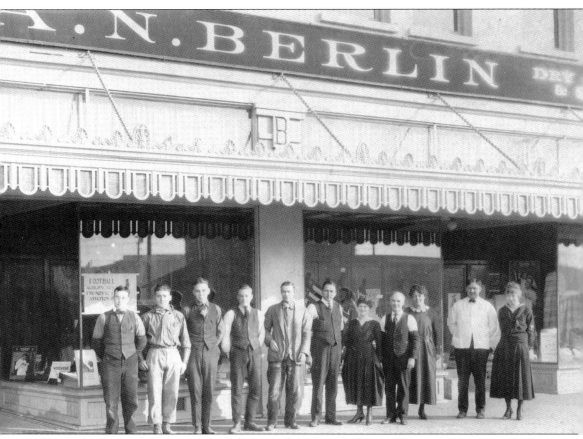

The Berlin General Store was run by John and Andrew Berlin. Both men were very involved in the Kent community in addition to running their business. Beginning with a wooden structure, their success allowed them to build a longer-lasting facility that remains to this day. They had a lucrative run for the first twenty years of the 20th century, then sold the business in order to retire. J.C. Penney bought the space, and after they too left, the space was broken up into smaller units. (Courtesy of Greater Kent Historical Society.)

Seven
Japanese Immigrants and World War II

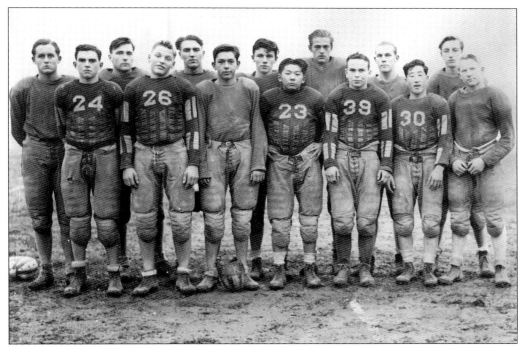

Kent was a very diverse city due to its influx of immigrants interested in farming the rich valley soil. The population was primarily English settlers, but Scandinavian and Japanese immigrants also settled in the area. As the ethnic communities grew, so did the draw for other members of those communities to live with a tie to their native country. As a result, schools in the valley had racial integration in the first half of the 20th century. (Courtesy of Greater Kent Historical Society.)

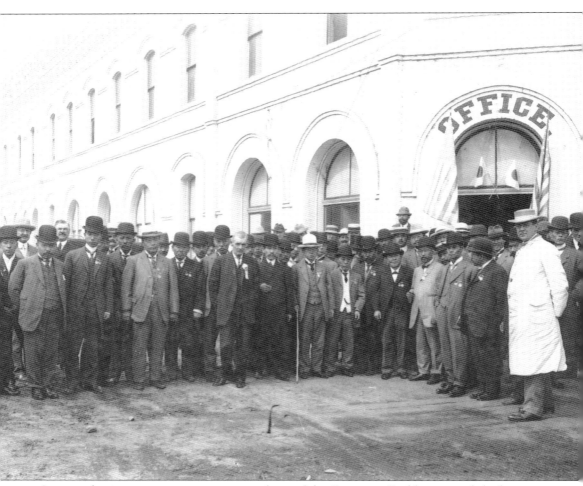

Japanese businessmen are seen posing in front of the Carnation Building toward the beginning of the 20th century. Western Washington was a popular place for Japanese immigrants. While most of the population in Kent were lettuce farmers, many were also businessmen who split their time between King County and Japan as dual residents, often owning property in both places. (Courtesy of Greater Kent Historical Society.)

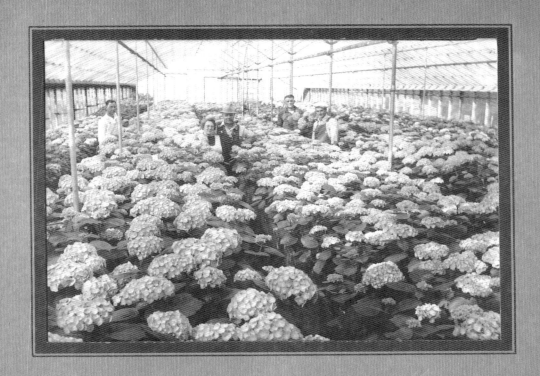

One of the oldest continuously open farmers markets in the United States is the Seattle Pike Place Market, beginning in 1907. Due to its proximity to Kent and a high number of visitors per day, it was popular for farmers in the White River Valley to sell produce in the market's stalls. In addition to food, flowers were a popular plant to grow in greenhouses built in the valley. Many Japanese farmers built hothouses, and floristry could be just as lucrative as agriculture, as it could be grown year-round. (Courtesy of Greater Kent Historical Society.)

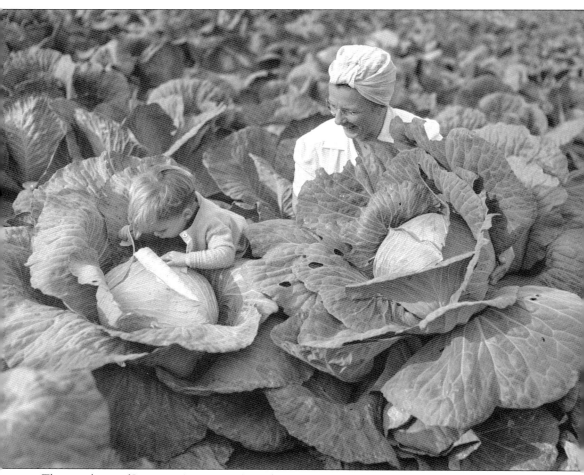

The expulsion of Japanese Americans from their homes in White River Valley left a severe shortage of residents to assist with the fall harvest. Mere weeks after relocation began, newspapers like the *Kent Advertiser Journal* began a call for volunteers to help with the lettuce and pea harvests. Students from the local schools and families with young children were conscripted to work in the fields, at a time when the need for farm labor was at an all-time high. (Courtesy of the *Seattle Post-Intelligencer* Collection, the Museum of History and Industry.)

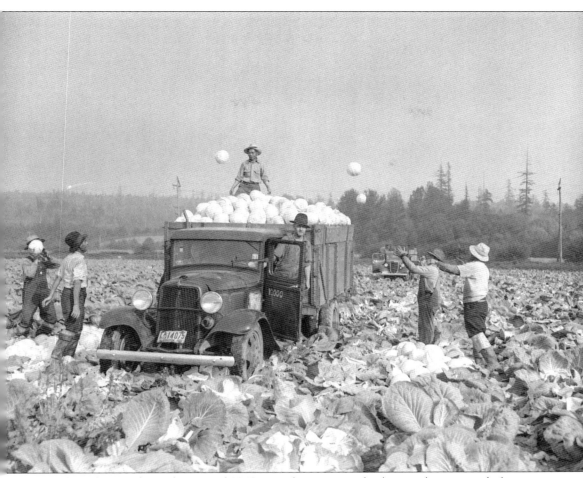

After the volunteer-driven harvest of 1942, one thing was made clear: without enough farming families to continue on through the war, some fields would be left fallow. Some of the land was sold immediately, with only fractions of the price sent to the Japanese owners in internment. Other fields sat unused for a bit longer. It was the beginning of the end of smaller, family-owned farms able to thrive in Kent. (Courtesy of the *Seattle Post-Intelligencer* Collection, the Museum of History and Industry.)

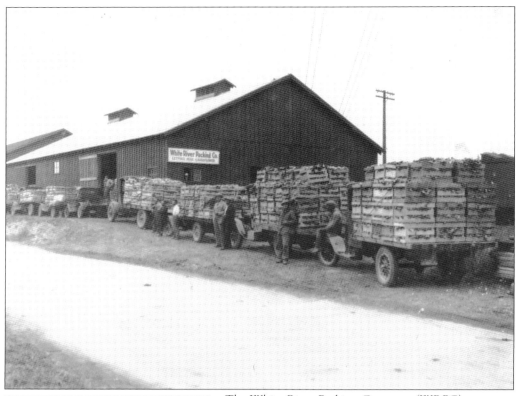

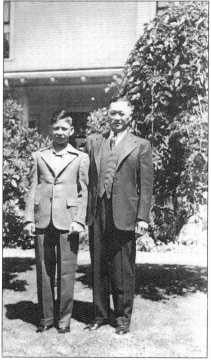

The White River Packing Company (WRPC) was a Japanese-owned and -operated business responsible for shipping lettuce out of state. Ernest K. Saito established the company and hired Japanese immigrants to manage the company's business affairs. Popular in the community, the WRPC even decorated its own float for the 1935 Lettuce Festival, creating a giant head of lettuce that wore a banner with the company's name. (Courtesy of Greater Kent Historical Society.)

Ernest K. Saito and his son Ray pose for a picture in front of their house in 1937. Ernest was the founder and owner of the White River Packing Company, a company most well-known for shipping lettuce from valley farms. Born in Japan, he settled in Kent and ended up buying the Bereiter mansion (pictured) for himself and his family. Ray was born in the United States. Sadly, both men were interned after Executive Order 9066 declared all Americans of Japanese heritage on the West Coast to be forcefully relocated. Unable to maintain ownership of his property, Saito bequeathed the house to his stepdaughter Thelma. (Courtesy of Greater Kent Historical Society.)

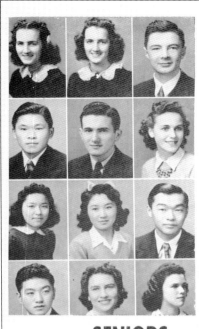

JEAN GRUNGSTAD—"Laff darn you, laff." Kay Hi Staff 4; Music Meet 2; Operetta 2; Girls' Glee 2; Junior Prom Committee 3.
IRENE GRUNGSTAD—"What, another one?" Kay Hi Staff 4; Operetta 2; Music Meet 2; Junior Prom Committee 3; Girls' Glee 2.
PETER HALLOCK—"I'm in the mood for music." Operetta 2, 4; Vaudeville 3; Pep Band 2; Stage Crew 3, 4; Solo Meet 3, 4; Regional Music Meet 3, 4; Thespian 2, 3, 4; Pep Committee 4.
CHARLES HAMADA—"Work is the richest of all gold mines." F.F.A. 2, 3, 4; Basketball 3; Softball 4.
TIM HARN—"The answer to a maiden's prayer." Vigilantes 3, 4; Home Room Pres. 3; Sec. 4; Football 2, 4; Smoker 2, 3, 4; Basketball Mgr. 4; Fire Squad 2, 3, 4.
VEVA HICKS—"I never knew." Entered in Senior year. Home Room Sec. 4; All-school play 4; Kay Hi Staff 4; Hobby: Writing letters.
BETTY HIRANAKA—"The silent type." Vaudeville 3; S.O.S. 4; Criterion 4; Hobby: Dancing.
MARY HORI—"Always willing." Girls' Athletics 2, 3, 4; Criterion 3.
KUNI HIUGA—"Why doesn't someone tell me these things?" F.F.A. 2, 3, 4; F.F.A. Basketball 3, 4; Softball 2, 3, 4; Paddle Squad 4; Smoker 4. Hobby - Sports.
4; Vaudeville 3; Kay Hi Staff 4; Girls' Honor 4; Torch Honor 2, 3, 4; Vice-Pres. S.O.S. 4.
CHARLIE IKEDA—"Laugh and the world laughs with you." F.F.A. 2, 3, 4; Judging 3, 4; W.S.C. Conference 3; Criterion 4; Hobby: Collecting stamps.
ANNA MARIE JARVIS—"Don't worry about me." Torch Honor Club 2; Criterion 4; Hobby: Photograhpy.
HELEN JONES—"Are there any more at home like you?" Vice-Pres. Girls' Honor 4; Music Meet 2, 3; Winter Play 3, 4; Vaudeville 3; Girls' Athletics 2; Nonette 2, 3.

Beauties and the beast.
—Ruth Stendal, Tim Harn, Helen Jones

SENIORS

GLORIA KASSNER—"I know another good one, too." Entered from West Seattle. S.O.S. 4; Home Room Pres. 3; Hobby: Skiing.
JIM KOGA—Natural talent. Sec. Home Room 3; Track Mgr. 3, 4; K-Club 4; Hobby: Model airplane building.
GEORGE KOMOTO—"Did you get this problem?" F.F.A. 2, 3, 4; Judging 3; Basketball 4; Ambition: Successful business man.

ROLAND KROHN—
JEAN KUCHENBECKER—Our Spinster. Girls' Athletics 2, 3, 4; Girls' Honor Club 4; S.O.S. 4; Vice-Pres. Home Room 2, 3, 4; Sec. 2 Criterion 3, 4; Vaudeville 3.
DICK LARSON—"If it's good, then I want it." Basketball 2, 3; Track 2, 3, 4; Football 4; Torch Honor 2, 3, 4; Smoker 2, 4; K-Club 3, 4; Fireman 4; Boys' Club Council 4.

LOIS LAWRENCE—Sweet Remembrance. S.O.S. 4; Operetta 2; Oratorical 3; Girls' Glee 2, 3; Hobby: Music.
FRED LEBER—Hot on the trumpet. Pep Band 2, 3, 4; Debate 3, 4; Football 3, 4; Softball 3, 4; FireSquad 2, 3, 4; Solo Meet 2, 3, 4; Jr. Class Pres. 2; Boys' Club Pres. 4.
ANNA MARIE LEISINGER—The age of innocence. Kay Hi Staff 4; Vice-Pres. Home Room 2; Operetta 2; Music Meet 2; Girls' Glee 2.

BOB LEWIS—There will come a time. Basketball 3; Poster Committee 4; Hobby: Model Airplanes.
JACK LOOP—"Today I am a man." Football 2, 3, 4; Smoker 3. Hobby: Tumbling.
DONALD MACDONALD—Free to love. Track 2, 3, 4; Paddle Squad 3; K-Club 3, 4; Hobby: Collecting stamps and postmarks.

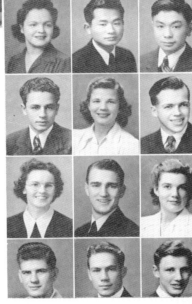

The "evacuation" order was to be completed in May, meaning that Japanese students intending to graduate with their high school class were unable to attend the official ceremony in June. Of the 92 Kent High School (KHS) students who graduated in 1942, a total of 24 were of Japanese descent. KHS decided to put together an unofficial ceremony three weeks earlier to honor the students. On the day of the official commencement ceremony, the *Kent News-Journal* ran the yearbook pictures of all 92 graduating seniors. (Courtesy of Greater Kent Historical Society.)

WRA–135 (Rev.)

UNITED STATES WAR RELOCATION AUTHORITY

Citizen's Leave Permit for Work Group

THIS IS TO CERTIFY THAT

Bob Y. Endo

a United States Citizen residing within

Tule Lake

Relocation Area is allowed to leave such area on

April 20 _____, 19 43, to go to

Dayton, Washington

and is required to return to such area not later than

November 20, _____, 19 43, unless he is issued a written extension of leave. This leave is subject to the terms of the regulations of the War Relocation Authority relating to issuance of leave for departure from a relocation area and subject to any special conditions or restrictions set forth on the reverse side hereof.

3165

(Project Director) 18—33267–1

War relocation, in addition to incarcerating thousands of Americans, had the effect of depleting the workforce everywhere, notably in Kent. After Executive Order 9066 was carried out, valley farmlands were left with a deficit of labor. For weeks, there were reports of a shortage of farm labor for the lettuce and cauliflower harvest in 1942. Work-leave authorization was granted for Japanese Americans to leave internment camps for short periods of time in 1943. (Courtesy of Greater Kent Historical Society.)

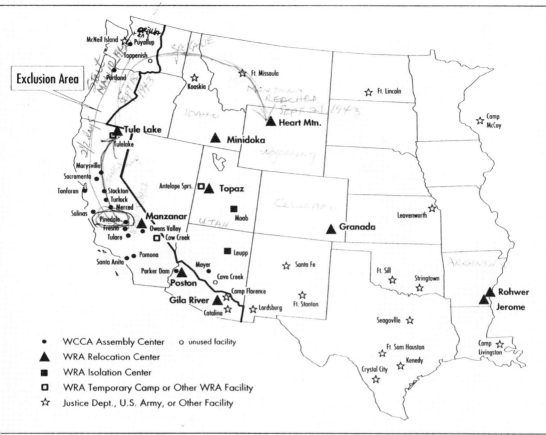

Figure 1.1. Sites in the western U.S. associated with the relocation of Japanese Americans during World War II.

This relocation map annotated by Alice Taketa Nakao (KHS class of 1944) includes dates and locations to which she and her family were forcibly moved during the war. Her father had purchased farmland in Orillia on April 18, 1942. The family was forced to abandon it on May 10 of that same year. As they were not allowed to return for the harvest, they never received the full amount of the money they would have made that year. Alice Nakao never resettled in Kent. Although she visited, she relocated to Cleveland and worked for NASA. (Courtesy of Greater Kent Historical Society.)

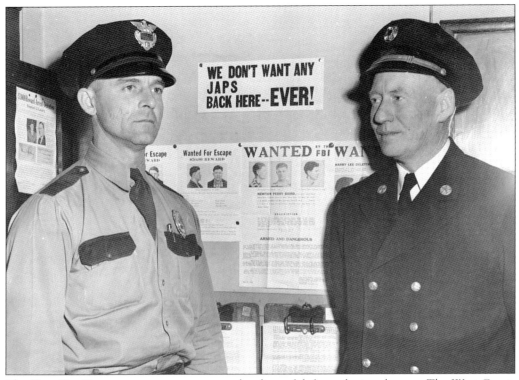

The Kent Fire Department was seen as another line of defense during the war. The West Coast, at risk of another attack from the Pacific, was an area under scrutiny. Even after the expulsion of Japanese Americans, racial prejudice was encouraged, even by those who vowed to protect and serve. (Courtesy of Greater Kent Historical Society.)

One of the ways Kent's residents could serve the war effort from home was the Civil Air Patrol. Both men and women alike could train for light military duty and assist in running air raid drills, a serious concern for the West Coast after the bombing of Pearl Harbor. (Courtesy of Greater Kent Historical Society.)

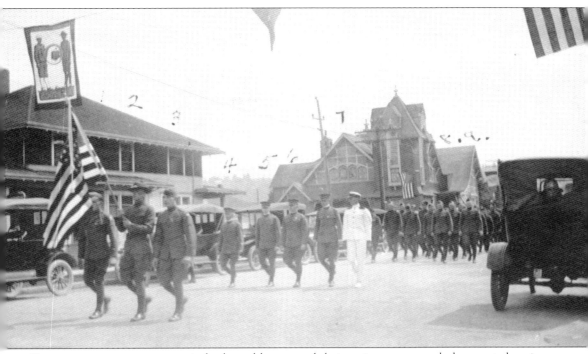

Kent gave young men to serve in both world wars, and their actions were regularly reported on in the *Advertiser Journal* and, later, the *Kent Advertiser*. Here, they are honored in a parade after World War I through the streets of Kent. Serving in the military was highly respected in the community, and even in smaller events, veterans in the festivities were encouraged to wear their uniforms. (Courtesy of Greater Kent Historical Society.)

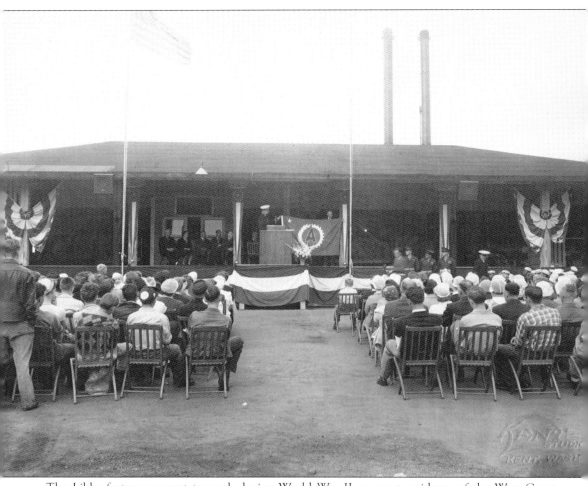

The Libby factory was put to work during World War II, as most residents of the West Coast were during that time. However, after their service canning rations for American soldiers, their work earned them a special award for exemplary service, presented in the factory. The ceremony was attended by Mayor R.E. Wooden, who helped present the award. (Courtesy of Greater Kent Historical Society.)

Eight

VANISHING HISTORY AND THE POSTWAR YEARS

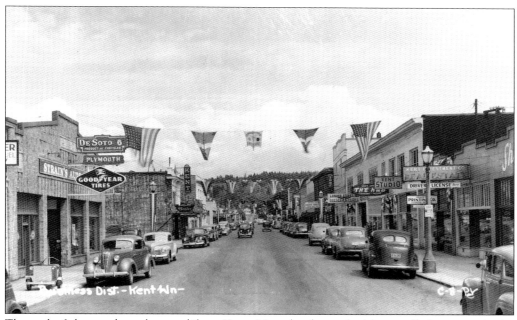

The end of the war brought new life to Kent. Many local men had been called to serve in the armed forces and many women had taken jobs at Boeing. The lapse in private farms made way for large commercial farms to provide agricultural labor. Kent's business district was flourishing in the ensuing economic boom. Further up on East Hill, in the background, more homes were being built. The railroad continued to run through Kent and even expanded to both freight trains for farm goods and passenger trains to take locals north to Seattle or South to Tacoma. (Courtesy of Greater Kent Historical Society.)

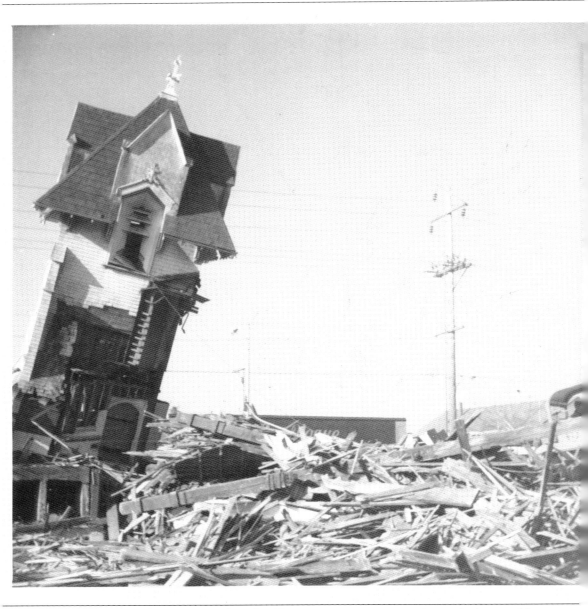

After the postwar boom, it was clear that Kent was experiencing rapid growth that would soon necessitate city-wide construction. Some older buildings were not feasible to preserve and were torn down or moved to new locations entirely. The Kent train station was relocated twice, and the Christian church was moved once. The Methodist church was demolished, with the only surviving piece being the church's spire. (Courtesy of Greater Kent Historical Society.)

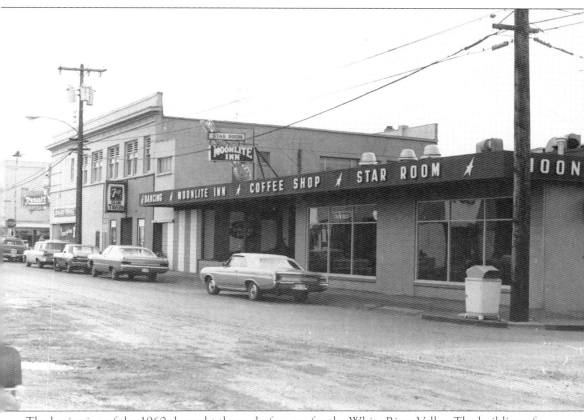

The beginning of the 1960s brought the end of an era for the White River Valley. The building of the Howard Hanson Dam in 1961 was primarily to control the headwaters of the Green River and keep the river's depth consistent for the native fish population. Ever since, flooding in the valley has decreased significantly. The average rainfall still maintains rich topsoil for local farmers, but the waters never rise high enough to cause widespread damage to infrastructure the way it once did. (Courtesy of Greater Kent Historical Society.)

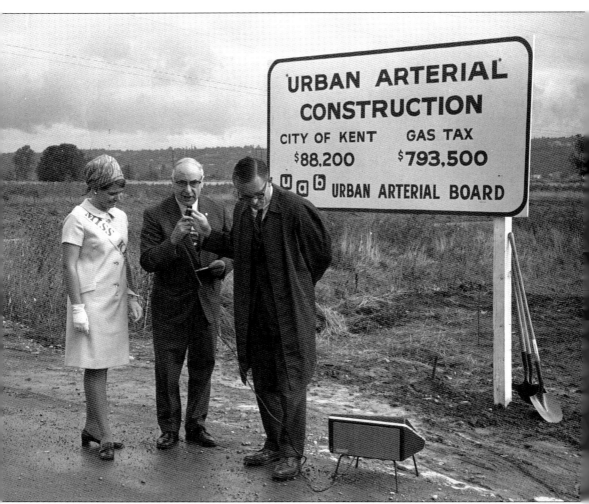

Miss Kent, Mayor Alexander Thornton (center), and Gerry Anderson pose for a picture of the ground breaking for urban arterial construction in the 1960s. By the end of his term, Mayor Thornton had been the longest-running mayor in Kent's history. (Courtesy of Greater Kent Historical Society.)

After World War II, Kent was beginning to gain attention from major companies and corporations. Boeing Aerospace, which began in the state of Washington, chose Kent to be the next location to build space technology for NASA and built the Apollo moon buggy in the valley. Later, Recreational Equipment Incorporated, or REI, also chose Kent for its first headquarters. (Courtesy of Greater Kent Historical Society.)

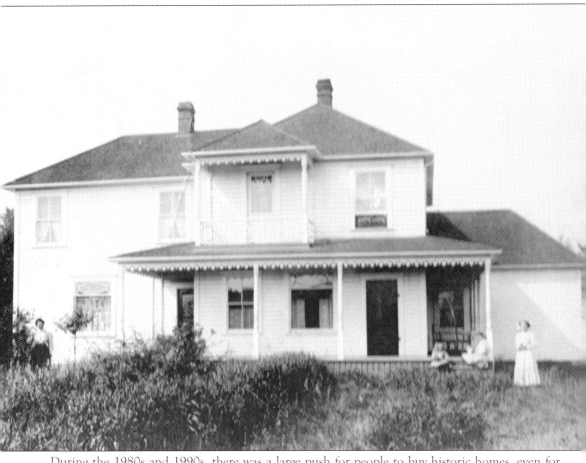

During the 1980s and 1990s, there was a large push for people to buy historic homes, even for them to be moved elsewhere so the land could be developed. Older houses were expensive to maintain, and more job opportunities meant more residential areas needed to be rezoned. Families still living in the homes placed ads in local papers and gave interviews asking buyers to save these historic buildings. The Neely house, pictured here, was bought by the city and preserved. Others were bought by developers, and the land was cleared. (Courtesy of Greater Kent Historical Society.)

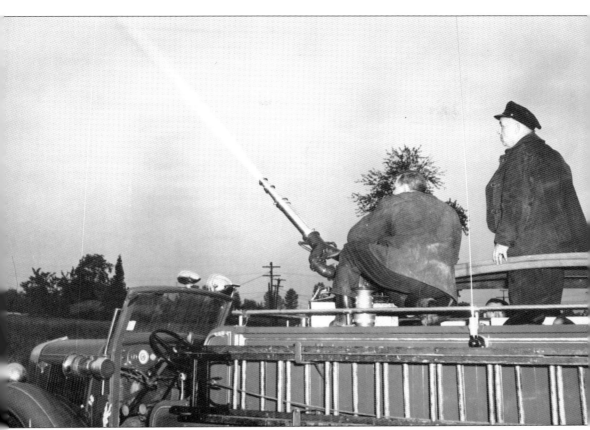

Fire training for the Kent Fire Department often took place on real houses that could not sell, often while the former tenants stood by and watched. In order to see and experience how real houses would burn, the fire department would buy condemned homesteads and cabins and set them ablaze to train recruits. (Courtesy of Greater Kent Historical Society.)

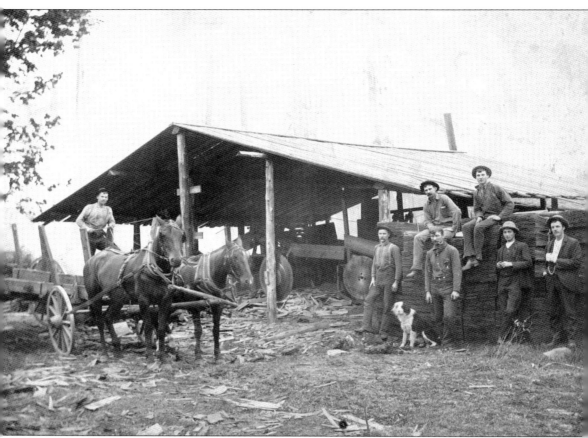

One of the houses declared a historic landmark in Kent is the Neely-Soames Historic Homestead. Built in 1885, it is one of the oldest surviving houses in Kent. The Neely family was a settler family who farmed and owned a sawmill for the processing of lumber. With the money from their success, the Neely family built a large homestead that is now an event space under the governance of the Kent Parks service. (Courtesy of Greater Kent Historical Society.)

The Greater Kent Historical Society is currently located in the Bereiter mansion, built by Emil Bereiter, who served as Kent's mayor from 1912 to 1913. He bought the land in 1907 in order to build a house for his wife and sons. They lived in the house until Emil's death in 1915. The mansion changed hands for decades and was eventually purchased in 1996 by the city for restoration to act as a living history museum. (Courtesy of Greater Kent Historical Society.)

A few blocks south of Kent Station is downtown Kent, also called the Historic District. Not all the buildings are original to the formation of Kent or even the postwar growth, but areas like the Guiberson block have been preserved and host modern businesses. Once housing the first official post office, the Guiberson block is now made up of five attached buildings. The original facade remains, and although the leaded glass windows no longer let in light, they are still maintained. (Courtesy of Greater Kent Historical Society.)

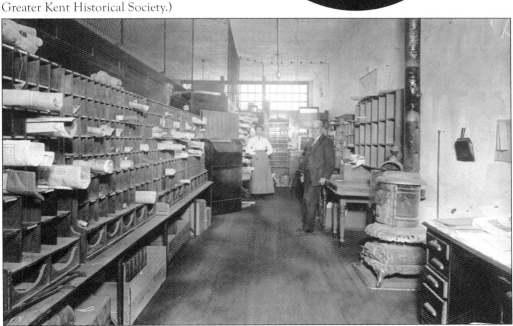

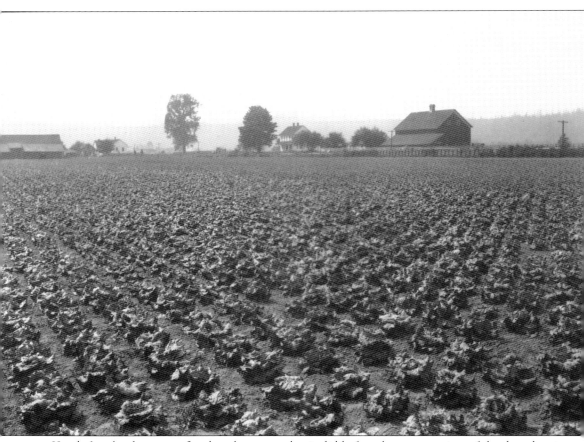

Kent's farmland may not flood to the extent that it did before the construction of the dam, but it still receives enough water from rainfall to stay just as fertile as it had been in years past. Lettuce, squash, and peas are still staples to valley farmers. Larger farms like the Smith Brothers and Carpinito still rely on Kent's soil. (Courtesy of Greater Kent Historical Society.)

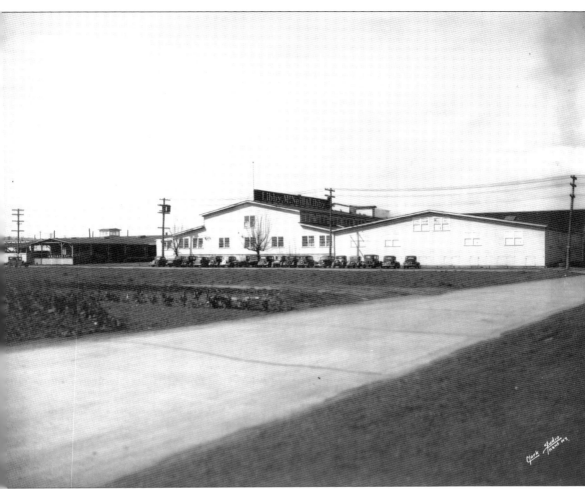

Although there are still large-scale and family farms run in the valley, certain areas have been rezoned as commercial and residential. The land where the Libby factory used to stand has been made into a parking garage for the train station, and the foreground in this photograph is now businesses with apartments above. The area is now referred to as Kent Commons and includes Kent Station, the library, and the courthouse. (Courtesy of Greater Kent Historical Society.)

DISCOVER THOUSANDS OF LOCAL HISTORY BOOKS
FEATURING MILLIONS OF VINTAGE IMAGES

Arcadia Publishing, the leading local history publisher in the United States, is committed to making history accessible and meaningful through publishing books that celebrate and preserve the heritage of America's people and places.

Find more books like this at
www.arcadiapublishing.com

Search for your hometown history, your old stomping grounds, and even your favorite sports team.

Consistent with our mission to preserve history on a local level, this book was printed in South Carolina on American-made paper and manufactured entirely in the United States. Products carrying the accredited Forest Stewardship Council (FSC) label are printed on 100 percent FSC-certified paper.